THE LAST DAYS
OF BR STEAM
1962–1968

David Christie

30127 08553817 6

AMBERLEY

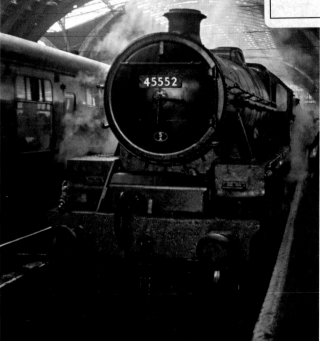

45552 *Silver Jubilee* on a Special at Paddington Station. October 1963.

Front cover: Standard 5MT 73013 at Tring. 25 May 1963.

Back cover: J27 65892 at Silksworth Mine, Sunderland. 20 June 1967.

First published 2017

Amberley Publishing
The Hill, Stroud
Gloucestershire, GL5 4EP

www.amberley-books.com

Copyright © David Christie, 2017

The right of David Christie to be identified as
the Author of this work has been asserted in
accordance with the Copyrights, Designs and
Patents Act 1988.

ISBN 978 1 4456 6806 2 (print)
ISBN 978 1 4456 6807 9 (ebook)

All rights reserved. No part of this book may be
reprinted or reproduced or utilised in any form
or by any electronic, mechanical or other means,
now known or hereafter invented, including
photocopying and recording, or in any information
storage or retrieval system, without the permission
in writing from the Publishers.

British Library Cataloguing in Publication Data.
A catalogue record for this book is available from
the British Library.

Origination by Amberley Publishing.
Printed in the UK.

Contents

Introduction

My railway photography started in September 1962 with the intention of recording just a few days revisiting my favourite London terminal stations from my trainspotting days. Having left school in 1959, the intervening three years had seen other interests taken precedence, as was the way of things, but travelling to London one day in 1962 it suddenly dawned on me that there was virtually no steam to be seen. My line was the Great Eastern, which lost steam earlier than most.

This spurred me on to allocate three days to record steam in London before it was too late, with my newly purchased Petri 7 35mm camera, using colour transparency (slides) film. After many views of the images taken, a repeat performance at the London termini was on the cards in March 1963, which led to my first lineside trip, to Berkhamstead on the MR main line – a pretty poor effort but at least a start. A more satisfactory visit to Welwyn North – beyond the tunnels – followed in late April with Pangbourne (WR) and Tring (MR) in May. For some reason, lost in the mists of time, no more lineside trips were done in 1963 but instead I concentrated on stations and travelling on the remaining steam on the Southern Region.

My first Special photographed was in September at Victoria Station, being a double-headed train bound for the preserved Bluebell Railway, with superb locos, being the Caledonian Single 123 and the LSWR T9 No. 120. Another memorable Special was the arrival in Marylebone Station of LNER 4472 *Flying Scotsman* in April 1964 – my first sight of the loco.

1964 was to become my most prolific year with the discovery in April of the lines in the Isle of Wight – this steam paradise being revisited another six times in the next two years – but the year really took off with the purchase of a Midland Region Railrover ticket, valid for one week in late June. This was used to travel each day from London out to Shrewsbury, Crewe, Derby, Chester, Liverpool, Preston, and Carlisle. I was able to use services from Euston, St Pancras, Marylebone – and Paddington, as some of the former

GWR lines were now in the Midland Region. Following this I redressed the imbalance to some extent in July by travelling on the Eastern Region overnight to Newcastle – but the weather was pretty awful. In complete contrast there followed glorious late summer weather beginning in late August and continuing to mid-October, which was taken advantage of in trips to Salisbury, Basingstoke, Swindon, Chalford, Gloucester, and Oxford. The Isle of Wight was also included with two visits.

1965 kicked off in January with a visit to Betchworth to see the last weekend of steam on the Reading–Redhill line. The Western Region was next given some attention at Goring, Banbury, and Didcot. Two more trips were made to my favourite Isle of Wight in June and July before travelling to Scotland in late August, combining a family holiday with railway interest. Having ensured that we stayed at Bridge of Allan, near Stirling, I was able to witness the Indian summer of the A4s right on our doorstep. Trips were made to Perth and, for the freight interest, Thornton in Fife. It has, however, always been a cause for regret that I did not take the short journey from Stirling to Callander to photograph at the lovely old station there. Eight years on, in 1973, I witnessed the sad destruction of the station buildings first-hand, a few months after I and my parents moved house to Callander, just a few hundred yards from the old station, which became, inevitably, a car park.

Following on from this Scottish week, I was only able to do the one trip to Chester and Chirk while staying on holiday in North Wales.

1966 began with a farewell trip to the Isle of Wight in January but then came a strange absence of railway activity until another Scottish family holiday was planned for September to take in the remaining steam freight workings in Fife. Staying at Kinghorn, in a caravan site right under the line, I was able to savour the sounds of hard-working steam while lying in my bed at night! Having more use of the family car this time I was able to revisit Thornton (briefly seen in 1965 by train) and give the yard more attention. The Alloa area was also included – with one lineside spot becoming familiar some forty years on as a footpath when I came to live not far away in Tullibody. A further week's holiday in the Lake District (east) was useful for nearby Yanwath on the WCML, and a cross-country foray to West Hartlepool. The railway year finished for me in late October on the SR at Clapham.

1967 was a more prolific year, mainly due to finding a work colleague (Chris Scott) who had a like interest in railways, and also in the purchase of my first car – a fastback Hillman Imp Californian. More attention was paid to the Clapham area in January before visiting Woking and Deepcut in April. On 29 April, Chris and I experienced our last (well, it was mine, I don't know about Chris) main line run behind BR steam when we travelled behind Merchant Navy class 35028 *Clan Line* from Waterloo to Basingstoke. More Clapham lineside followed – emphasis being on the Southern in its last few months of

steam working. Come the middle of June, Chris and I took a week's holiday in my new car, barely two weeks old, and visited the North East, revisiting West Hartlepool and Sunderland, then over to the west at Shap and Tebay. A further trip on August Bank Holiday to the Tebay area was made with an additional friend on board. Apart from a few local (London) Specials seen, the year finished with our first dedicated visit to the Bluebell Railway in late October – this now being the only place in southern England where one could see steam.

 1968 and a three-day foray with Chris in early March to do the rounds of the remaining steam sheds in the Liverpool, Manchester, and Bolton areas. Then it was a case of preserved lines until 4 August – the last day of BR steam. My arrangements for this momentous event were unusual in that I had to drive to Manchester from Aberystwyth that morning (early!), having taken my parents there the previous day for a holiday. Getting to Manchester I picked up several friends and we then spent the day trying to photograph as many of the various Specials that we could. Unfortunately we missed some through late running, but ended up at Lostock Hall shed to see 70013 *Oliver Cromwell* eventually – she had been used on one of the trains we had missed earlier. So ended BR steam, with only *Flying Scotsman* being allowed to still run Specials for a few years before she went to the USA.

 The images were all taken (except for one trip where I hired a camera due to mine being repaired) with a Petri 7 35mm camera – about the size of a modern bridge camera without the zoom lens. This Petri had an f2.8 lens with a top 1/500 shutter speed. Colour transparency film was used from the start but it was a case of trial and error as to which brand to use. The problem with colour film in the sixties was its slow speed (sensitivity) – the slower the film the better reproduction, which ideal was obtained with Kodachrome II, at 25asa (equivalent to today's iso). Well, that was of little use for action photography so one had to go for the likes of Ektachrome or Kodachrome X, at 64asa. Throughout most of 1963 I seemed to favour 'High-Speed Ektachrome', which at 160asa was, at that time, very fast, to the detriment of heavy grain and lack of colour. I finally ditched this and kept to Kodachrome X for a few years until, in 1967, and having discovered that my new-found friends used Agfa CT18 (50asa), I switched to this which, with its successors, served me well until the eighties when I succumbed to the richness of Fuji Velvia. It's a different story these digital days when the restrictions of film speed and always carrying sufficient film are dealt with at a touch of a button. All original slides have been scanned using Epson V700/800 scanners at high-resolution, then corrected (mainly for colour loss/change) in Photoshop. One thing that cannot be changed (at least for the present) is sharpness, so I hope that you will make allowances for the occasional blur!

 So, here you have a selection of my more presentable images from the days of steam – a totally different world fifty years ago.

Chapter One

London Terminal Stations

KINGS CROSS

3 September 1962 – my first railway photograph, having decided on Kings Cross as the best station to start, being my favourite from my spotting days. Here is A4 class 60028 *Walter K. Whigham* departing, rather swamped by platform trolleys. This loco only had four months to go before withdrawal.

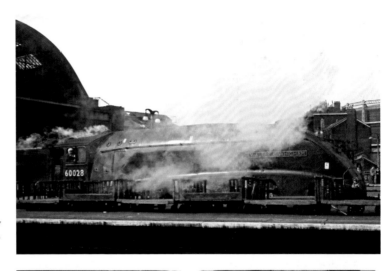

Also photographed on 3 September 1962, A3 class 60110 *Robert the Devil*, with the German-style smoke deflectors that were fitted to the class a few years earlier. The excellent turn-out is down to Kings Cross Top Shed, who kept their locos in immaculate condition. The rather too-close shot is down to my inexperience!

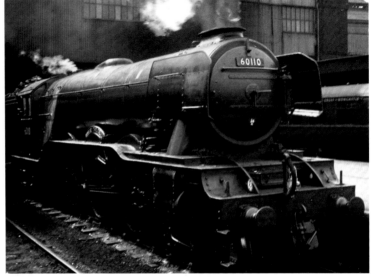

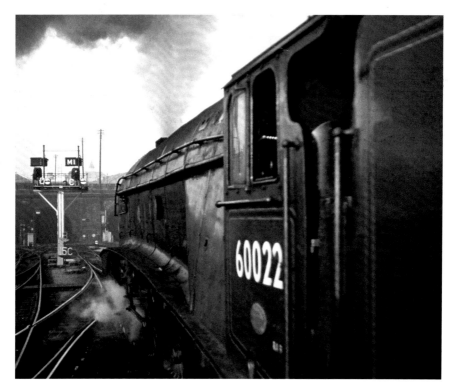

The most famous of all the A4s – 60022 *Mallard* – departs on 2 March 1963. She is now preserved, resplendent again in her original LNER Garter Blue livery, at the NRM, York. The world steam record holder at 126 mph.

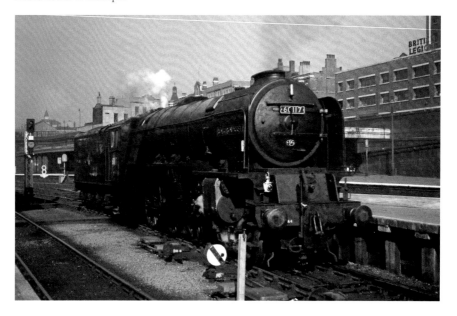

A1 class 60117 *Bois Roussel* backs out of the station after bringing in an express on 2 March 1963. She worked until July 1965 before being cut up – as were all of the class. Fortunately a new-build replica was constructed in 2008 as 60163 *Tornado*.

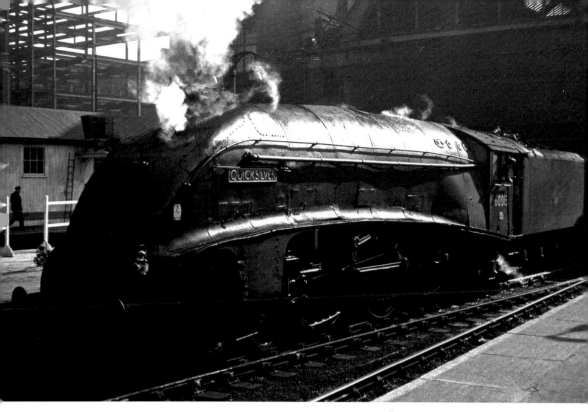

A4 60015 *Quicksilver* backs onto her train on 2 March 1963. Only the second A4 to be built (1935).

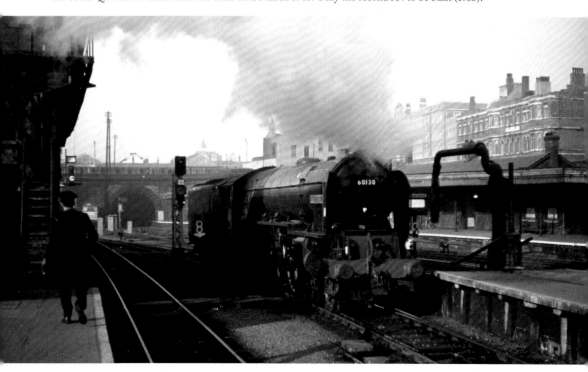

A1 60130 *Kestrel* backs out on 2 March 1963. Another smartly turned-out loco, a model of which was issued by Bachmann a few years ago now – and resides on my layout.

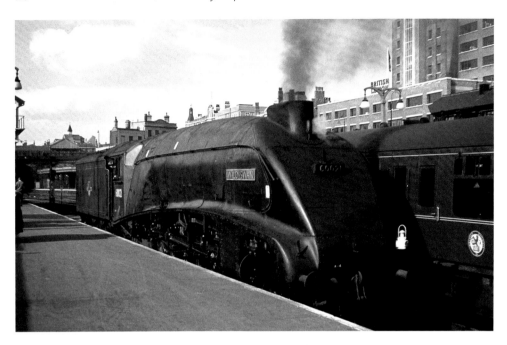

12 April 1963 and A4 60021 *Wild Swan* is another light engine backing out.

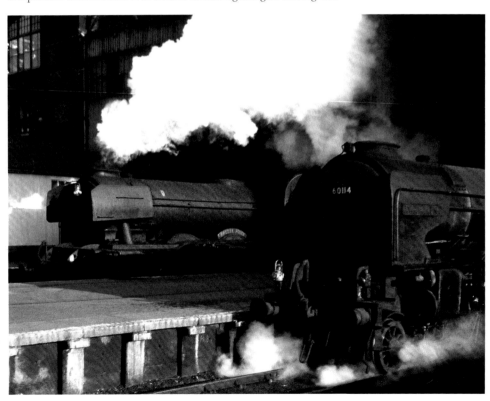

A busy late evening scene on 13 April 1963 with A1 60114 *W. P. Allen* waiting while A3 60061 *Pretty Polly* moves out light engine.

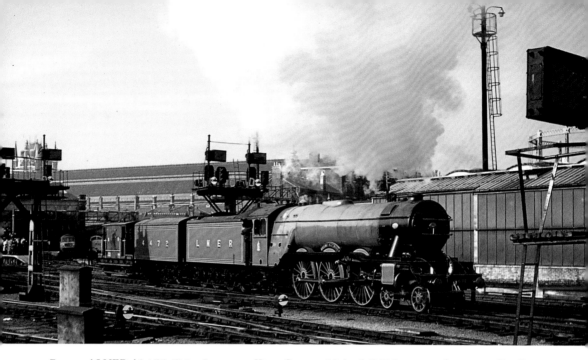

Preserved LNER A3 4472 *Flying Scotsman* at Kings Cross on 30 April 1967, four years after steam officially ceased at the station. This was her pre-USA period where a second tender (fitted in October 1966) solved the availability of water problem. Curiously this constituted a train so a brake van had to bring up the rear if any light engine running was necessary.

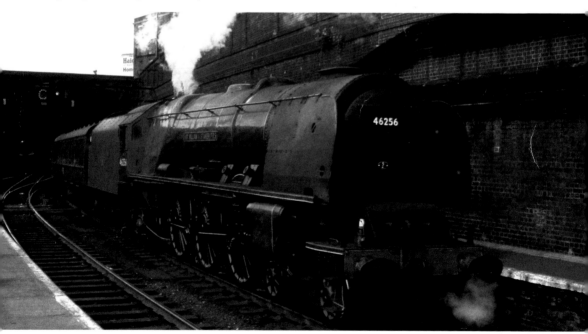

EUSTON

The second station to be visited on my first day, 3 September 1962, Euston was a labyrinth of platforms and difficult to get around to see what was happening. Here is Duchess class 46256 *Sir William A. Stanier* backing out after bringing in the *Shamrock*. These big red locos were always an impressive sight, but sadly were all gone by September 1964.

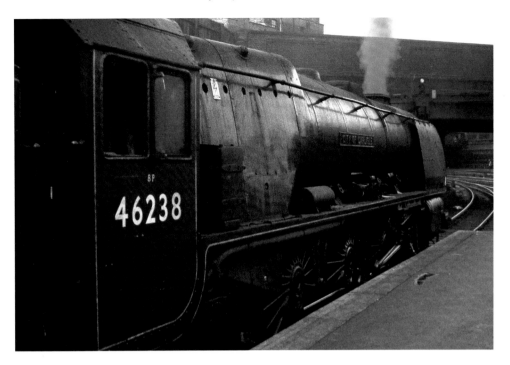

A return visit two days later, on 5 September 1962 with 46238 *City of Carlisle* waiting at the head of a Perth express. Sixteen out of the thirty-eight built were given the red treatment, with these generally being the ones to be seen, a green version being a rarity at this date.

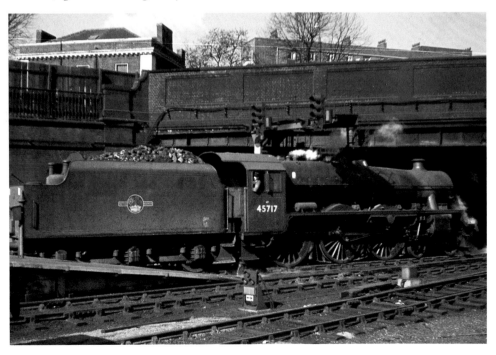

Jubilee class 45717 *Dauntless* backs towards her train at Euston, on 12 April 1963. She would be scrapped by the end of the year.

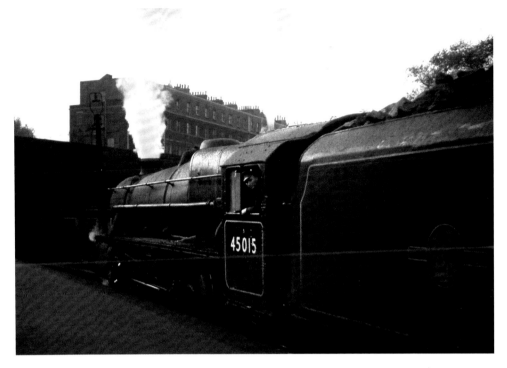

Black 5 45105 departs on the evening of 25 May 1963 with a returning FA Cup Special, substituting for a failed *Britannia*. She was a late survivor, not being withdrawn until December 1967.

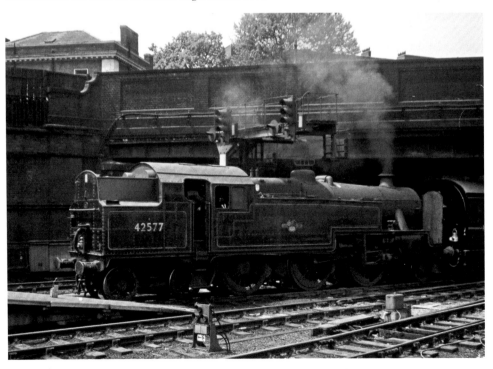

Banking out a train on 9 June 1963 is Stanier 4MT Tank 42577. Note the ex-works LMS carriage.

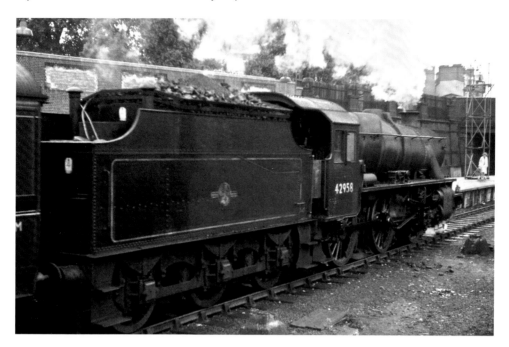

Stanier 2-6-0 5MT 42958 takes away the morning's Royal Mail stock on 17 August 1963. Only forty of this type were built as opposed to 840 of the 4-6-0 arrangement, so it was fairly unusual to see one. Euston by now was in the throes of demolition and was to completely lose its character.

PADDINGTON

GWR magnificence at Paddington on 5 September 1962, with 7027 *Thornbury Castle* and 6000 *King George V*. Both eventually survived into preservation.

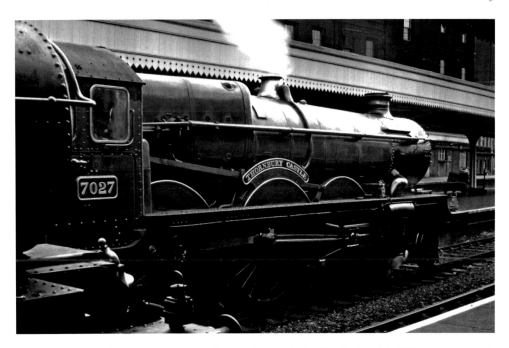

A beautifully cleaned-up *Thornbury Castle* showing the standard still to be found in 1962, but was to sadly descend to nameplate and cabside plate removal and no cleaning in the last three years of WR steam.

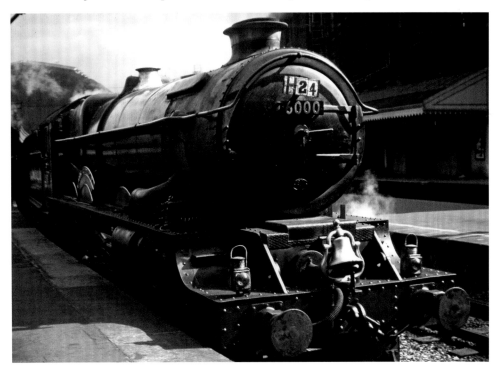

6000 *King George V* now departs from Paddington on 5 September 1962 – another case of getting too close! This loco would go on to spearhead the 'Return to Steam' in 1971 after three years (apart from 4472, which had a contract) of steamless BR.

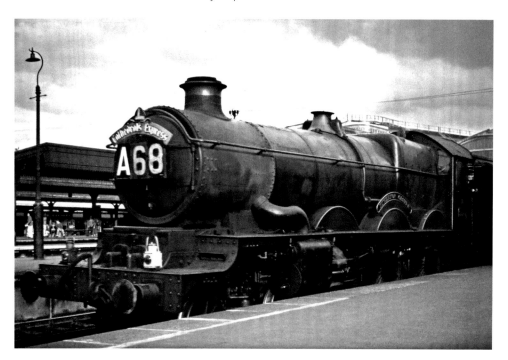

A rare use of a train name headboard is shown here; 'Cathedrals Express' adorning 5041 *Tiverton Castle* at Paddington on 5 September 1962. Someone still cared!

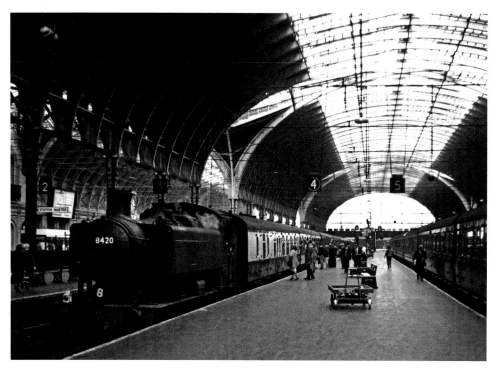

Under the overall roof on 6 October 1963 with Pannier tank 8420. At least one WR Chocolate and Cream liveried coach looks freshly painted.

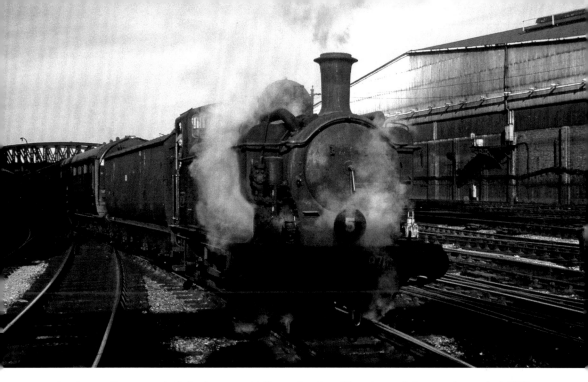

Condensing Pannier tank 9710 pilots in on 20 September 1964. Note the smokebox number applied GWR fashion to the buffer beam, in the absence of the BR plate. 9710 would only last a few more weeks.

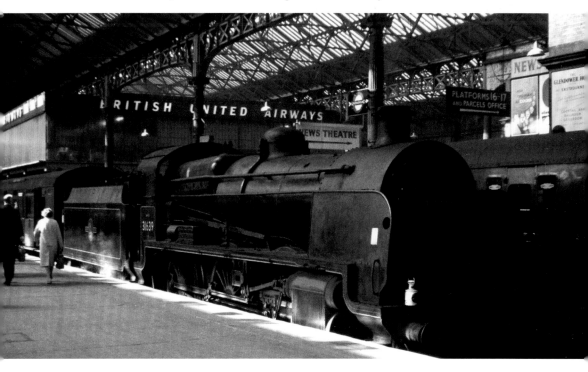

VICTORIA

On my only photographic visit here on 15 September 1963 to see my first Special, the loco used to pilot the stock was U class 31639 – here, looking nicely clean.

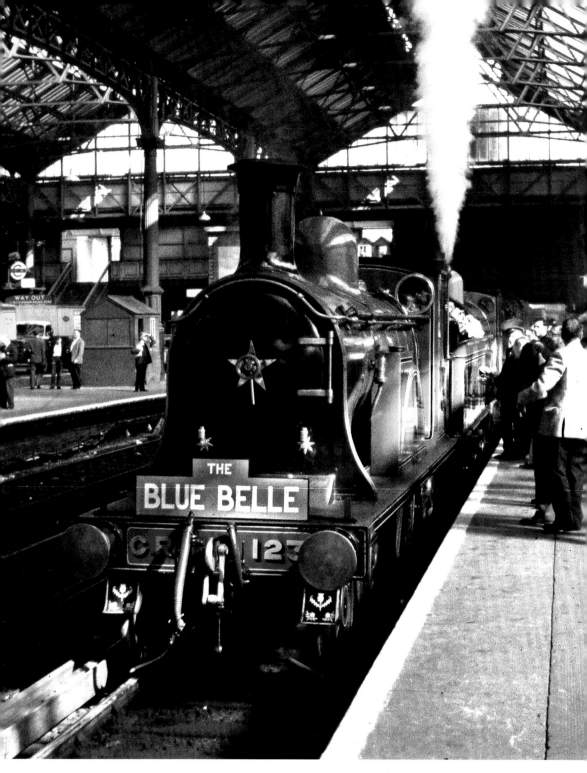

The Special was The Blue Belle, which was bound for... The Bluebell Railway. Double-headed by Caledonian Railway Single 123 with LSWR T9 120. Both locos were part of BR's collection with the T9 being the more fortunate of the two, being steamed around the country whereas CR 123 ended up behind museum doors.

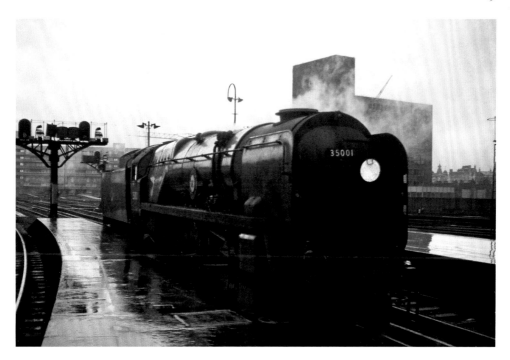

WATERLOO

A very wet and dismal 20 April 1963 on my first photographic visit to a station that wasn't one of my favourites. Here is Merchant Navy class 35001 *Channel Packet* backing out.

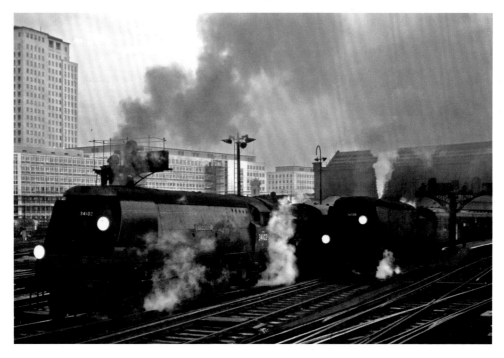

Early morning departures at Waterloo on 11 October 1964, taken while travelling to the IOW. A clean 34102 *Lapford* with a not-so-clean 34006 *Bude*, both being Unmodified West Countries.

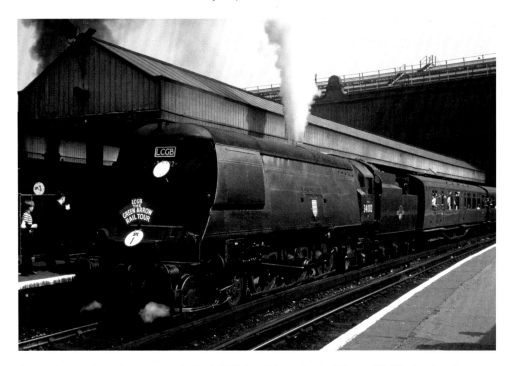

As can be seen from the headboard this LCGB Special was booked for an ER V2 class but I was not too displeased to find a nicely turned out Unmod. West Country in the form of 34002 *Salisbury* instead. Photographed on 3 July 1966.

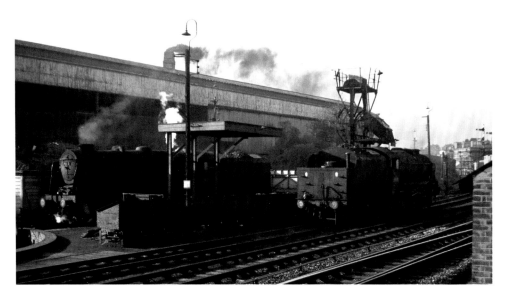

MARYLEBONE

Included here for two specific visits – generally nothing much happened at this station! The first visit was on 19 October 1963 to see the Royal Scot class locos that were being used on the ex-GCR line services. Here are 46125 *Third Caribinier* and 46143 *South Staffs Regiment* at the servicing area, visible from the platform end. Both locos were withdrawn just two months later.

Royal Scot class 46143 *South Staffs Regiment* on the turntable at Marylebone, its grimy condition is such that the number can barely be read. Photographed on 19 October 1963.

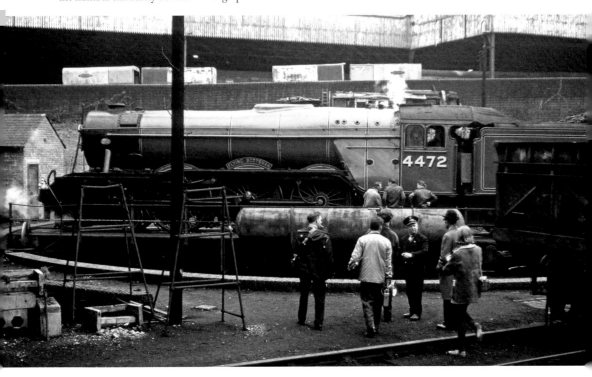

Same location, six months later – on 18 April 1964 with a far different scene as I get my first sight of LNER A3 4472 *Flying Scotsman* with a film crew heading over to the loco on the turntable, having just brought in a SLS Great Central Rail Tour. She appears here as originally restored to as near as was possible to her LNER state – a far cry from today's late BR look!

Chapter Two

Lineside

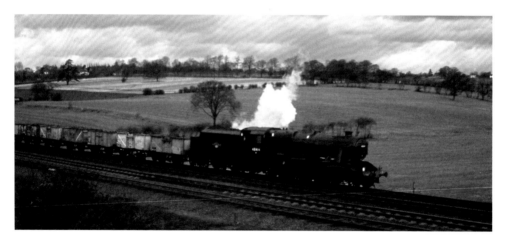

BERKHAMSTEAD

My first attempt at lineside photography was on 13 April 1963 at Berkhamstead on the MR main line. Ex-Works 8F 48414 is pictured on a coal train.

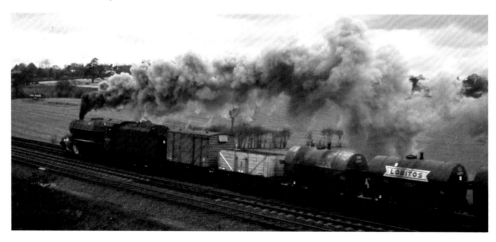

A more typical 8F 48531 passes in the opposite direction on a mixed goods.

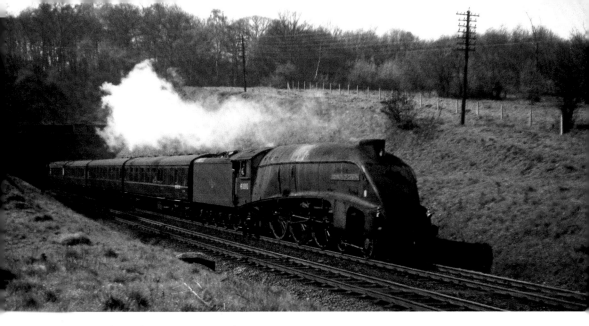

WELWYN (North)

My second proper try at the lineside was to a familiar spot from my childhood – Welwyn, on the GN line out of Kings Cross. This was very close to where my grandmother lived and family visits were usually an opportunity to see the trains. On this 'adult' occasion I walked north from Welwyn North Station over and between the two tunnels. Saturday 27 April 1963 was a far cry from two weeks previously with more line traffic and better weather. Here is A4 60010 *Dominion of Canada* emerging from the tunnel, northbound. She is now preserved – albeit in Canada!

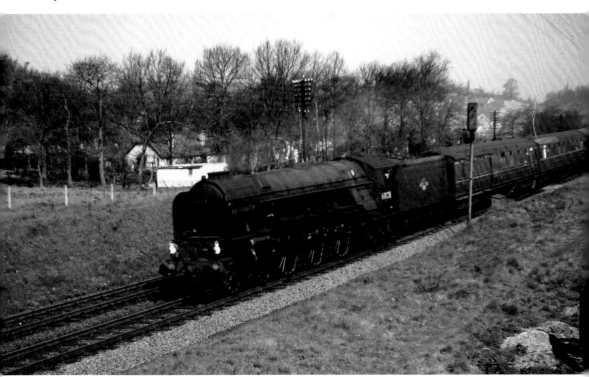

A1 60128 *Bongrace* heads south.

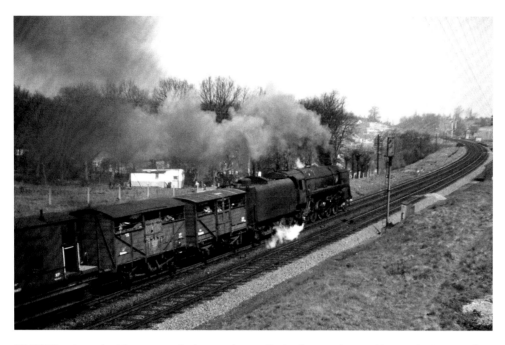

9F 92187 heads north with an extremely short cattle train. In the distance the signal box marks the start of the four-track lines.

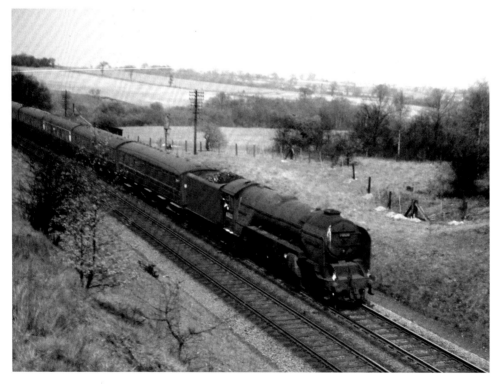

A2 60520 *Owen Tudor* southbound. This was one of New England's shed locos – the unloved appearance in sharp contrast to Top Shed's.

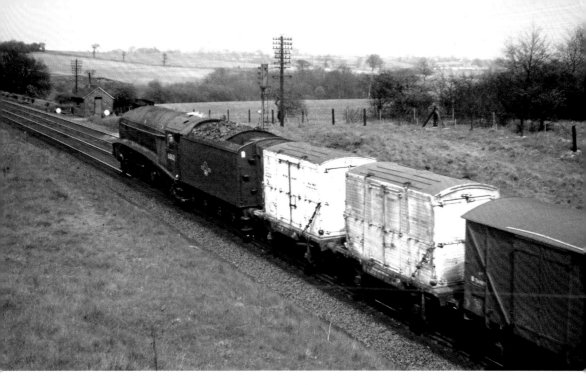

A4 60021 *Wild Swan* takes a fish train northbound. The A4s were regularly used at this time on fast freights but looked decidedly out of place doing so.

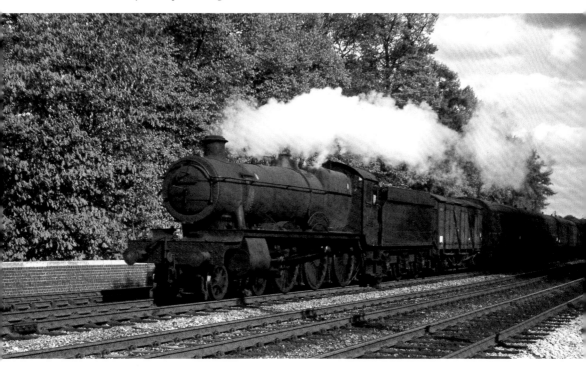

PANGBOURNE

It was the turn of the Western Region now with a lineside visit to Pangbourne on 11 May 1963. Here is 4910 *Blaisdon Hall* on a van train.

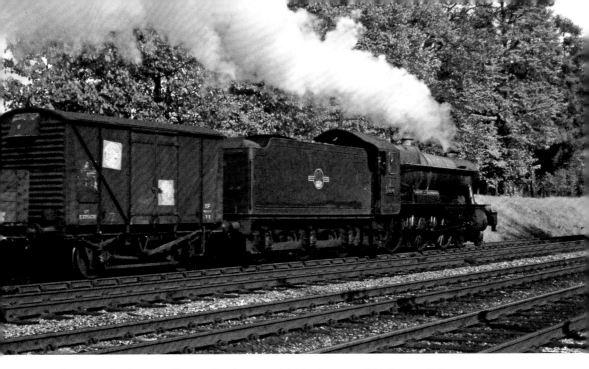

An unusual sight was a County class loco – and fairly clean too. 1014 *County of Glamorgan* passes on a goods train.

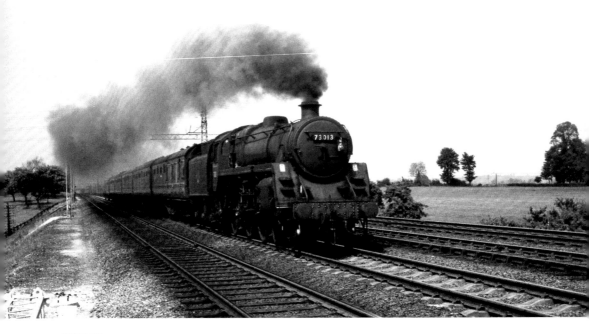

TRING

Another MR main line trip on 25 May 1963 to Tring where I walked four miles along the top of Tring Cutting to its end – and level track. This is the best of a poor batch due mainly to the position of the sun – right down the track. BR Standard 5MT 73013 steams past in fine style. The newly erected electrification masts are visible behind the train.

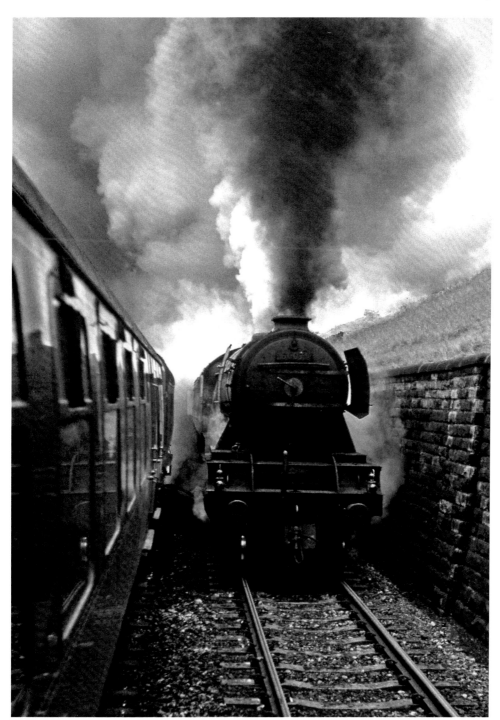

Near DURHAM

Fast forward now a whole year, with no lineside photography as I was concentrating mainly on station shots. This shot is not strictly lineside, being an out-the-window attempt during a long trip to Newcastle on 18 July 1964. A3 60071 *Tranquil* gives a terrific display as she passes, near Durham.

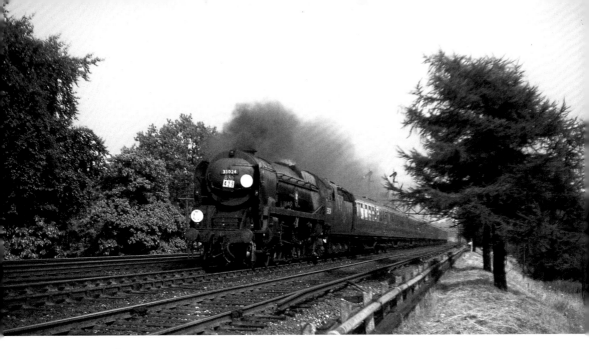

FARNBOROUGH

Back to the lineside with the start of a good spell of weather. On 22 August 1964, near Farnborough, Merchant Navy 35024 *East Asiatic Company* hurries past.

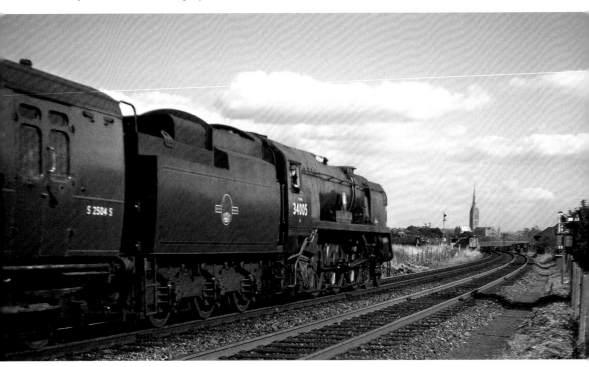

SALISBURY

With steam haulage (both ways with 35024 – previous image) from Waterloo, Salisbury was visited on 29 August 1964. Mod. West Country 34005 *Barnstaple* passes not far from the station, with the cathedral in the distance. She is in beautiful condition.

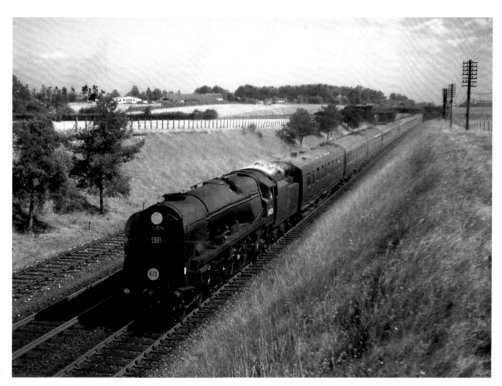

GRATELEY

A break of journey was made at Grateley, some ten miles from Salisbury. Here is Mod. West Country 34026 *Yes Tor*.

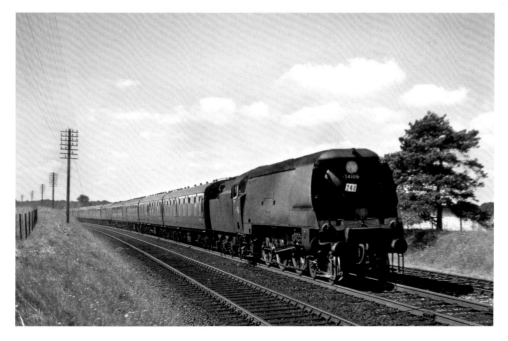

Unmod. West Country 34106 *Lydford*, with only one month's service left.

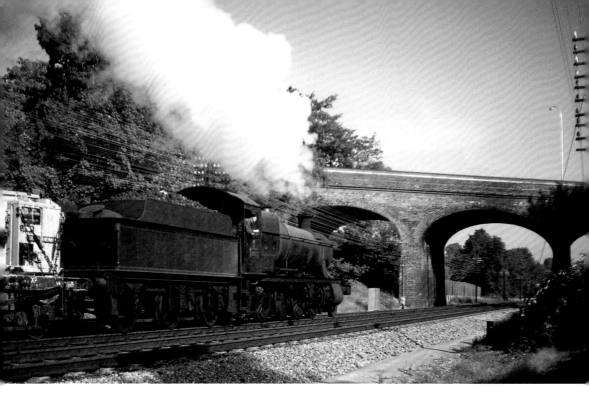

READING (West)

This spot was chosen to see two Specials running on 12 September 1964. While waiting for these WR28xx class 2893 passes on a goods.

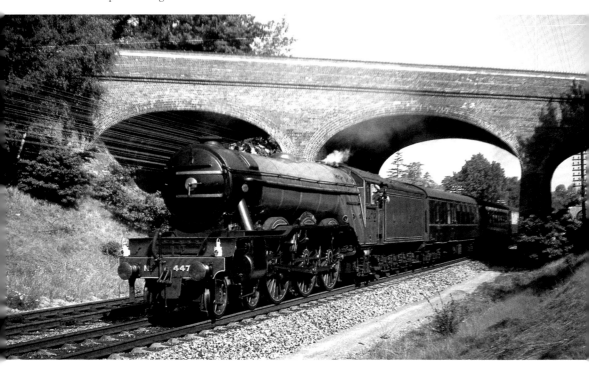

One of the Specials was 4472 *Flying Scotsman*, the other was cancelled.

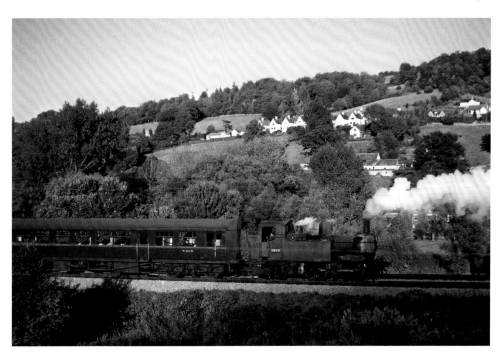

Near HAM MILL HALT, Gloucester–Chalford line

With one month to go before closure the Gloucester–Chalford Autotrain service was experienced on 26 September 1964. Here is 0-4-2 tank 1458 in the late afternoon pushing back towards Gloucester.

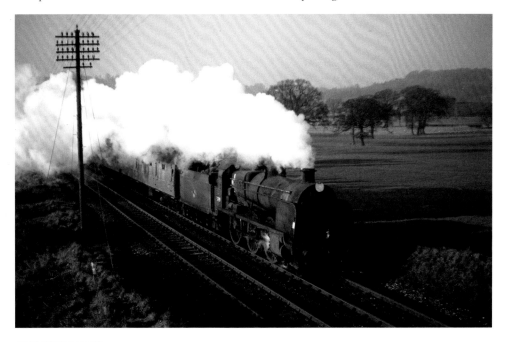

BETCHWORTH

On a very cold 2 January 1965, U class 31799 on the Reading–Redhill line is seen near Betchworth. Steam on this line would cease in a few weeks.

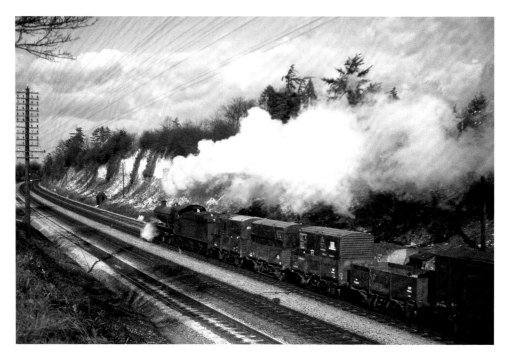

GORING

6983 *Otterington Hall* passes on a goods on 13 February 1965. A sad feature of most of the remaining ex-GWR locos was the removal of not only their nameplates but also cabside plates.

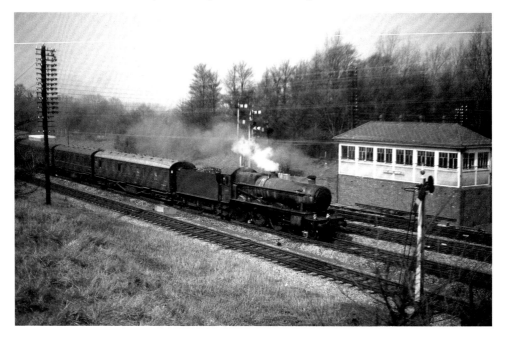

DIDCOT (West)

A visit on 3 April 1965 to take in a Clun Castle Special. 6931 *Aldborough Hall* brings a van train past the signal box.

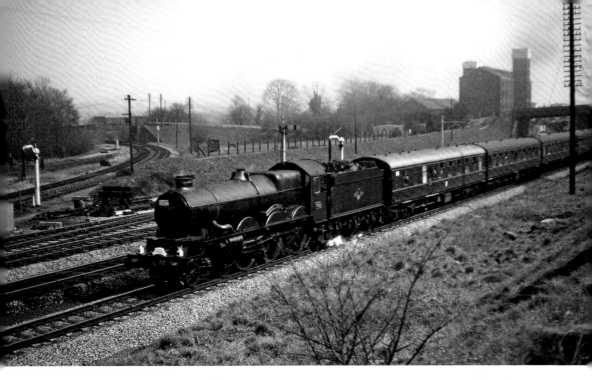

7029 *Clun Castle* on her Special passes the junction.

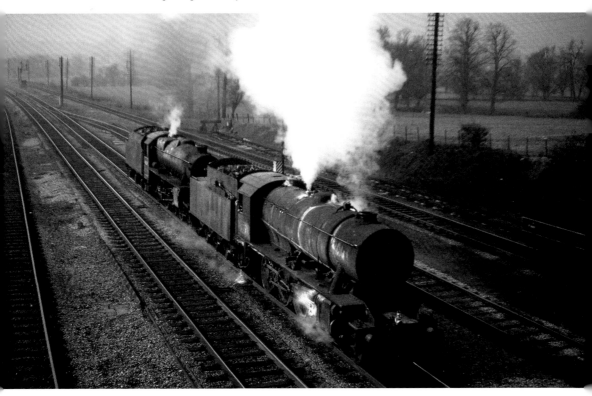

BANBURY

Near the station on 3 April 1965, WD 2-8-0 90232 coupled to 5MT 45208 hurries by.

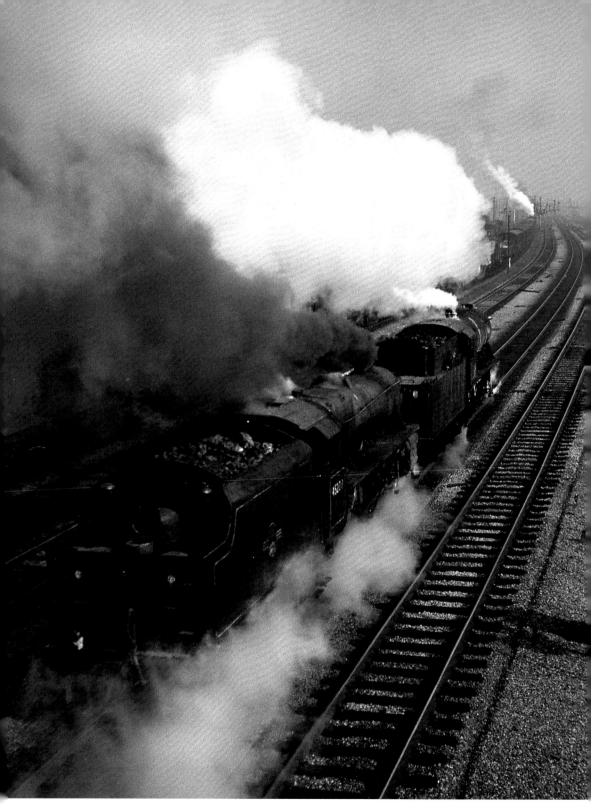

90232 and 45208 darken the skies near Banbury, with a goods train in the distance adding to the effect.

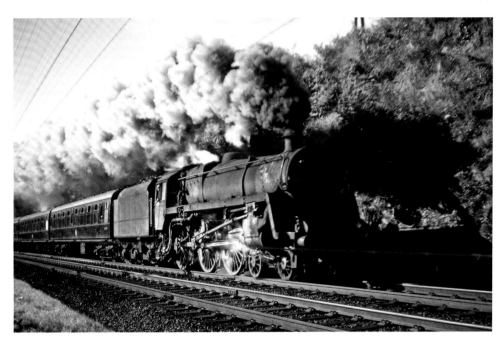

DUNBLANE

During a family holiday at Bridge of Allan an early morning short walk alongside the line brought me to a spot just short of Dunblane tunnel. Here is Caprotti Standard Class 5MT 73150 storming up the 1 in 100 bank, on the Grampian. Photographed on 23 August 1965.

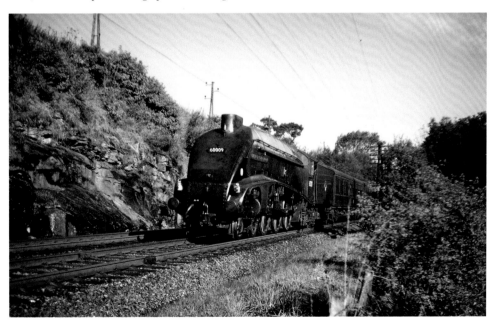

A4 60009 *Union of South Africa* brings the Bon Accord downgrade. This loco was one of the handful of A4s working the Glasgow–Aberdeen service – a fitting end to their careers. No. 9 was to become very well known to me from 1973 on when I came to live in Scotland, having been bought for preservation in 1966 to eventually run tours initially in Scotland, but latterly all over Britain.

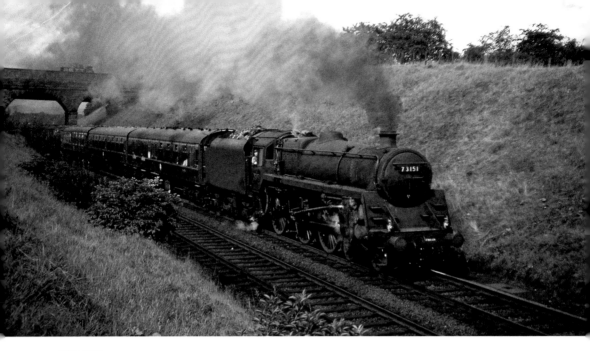

PERTH

Standard 5MT 73151 heads north out of Perth by Moncrieff tunnel on 25 August 1965. This loco was one of the Standard 5s fitted with Caprotti valve gear shedded at St Rollox, Glasgow.

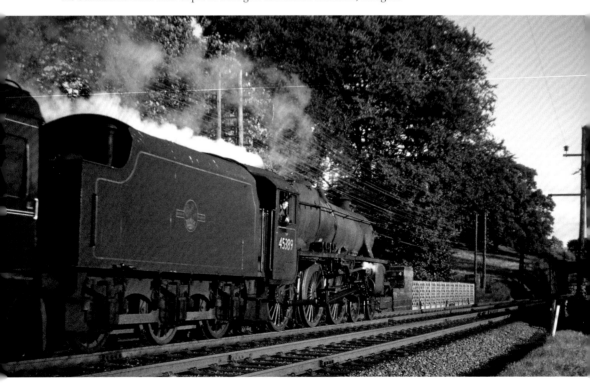

DUNBLANE

Black 5 45389 leaves Dunblane and heads south on a Callander–Edinburgh train. The larger size cabside numerals show well – a feature of some Scottish works. Photographed on 26 August 1965.

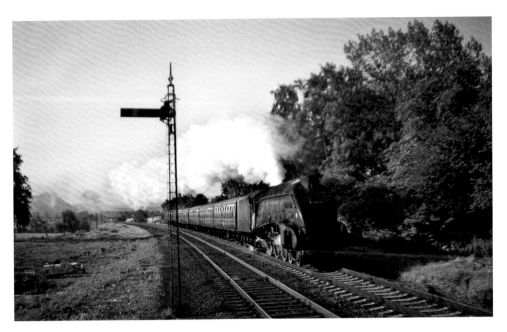

BRIDGE OF ALLAN

A4 60031 *Golden Plover* heads north on the Grampian with Stirling Castle in the distance. This loco was not so well kept as its sisters – also having a disfiguring diagonal yellow cabside stripe. This was applied to locos that were not allowed south of Crewe (due to the WCML electrification) but how it became attached to a 'Scottish' A4 is anybody's guess!

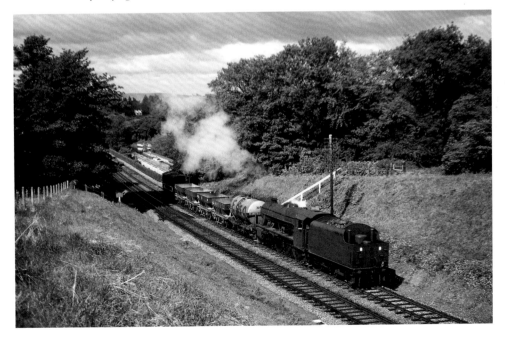

CHIRK

Following our Scottish holiday, we had a second week at Colwyn Bay. From here I travelled to Chester and then to Chirk for a day (1 September 1965). At the viaduct, here is 8F 48134 with a mixed freight.

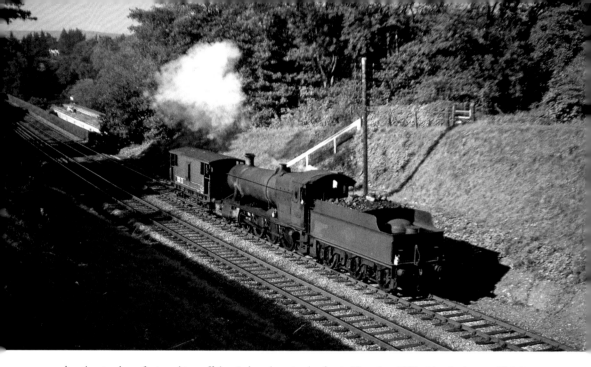

Another tender – first working off the viaduct, later in the day, is 28xx class 3855 with a brake van. This loco had just a few weeks left in service.

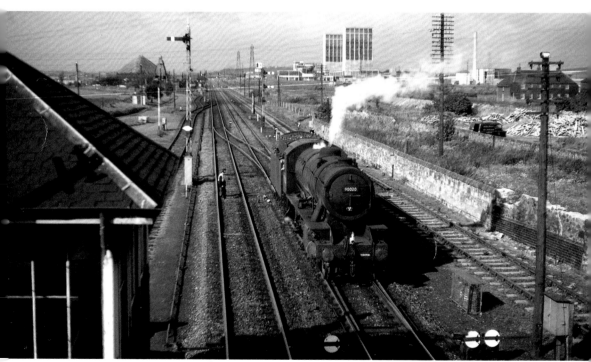

THORNTON

On another family holiday in Scotland, I managed to spend some time on 6 September 1966 at Thornton, in Fife, where most of the remaining steam in Central Scotland worked from. Here is WD 90020 backing light engine.

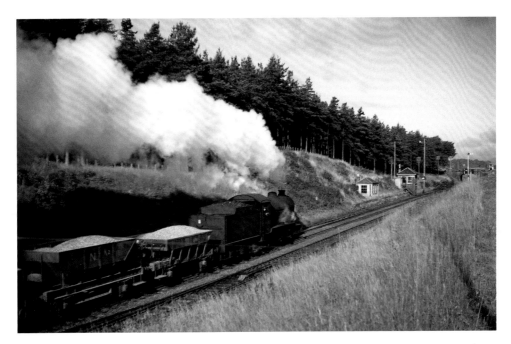

BOGSIDE, Dunfermline Line

J38 65934 on a ballast train near the signal box at Bogside on 8 September 1966. Some forty years later I would live in the area and regularly walk past this building, which still stood, but the railway line was now a cycleway/footpath.

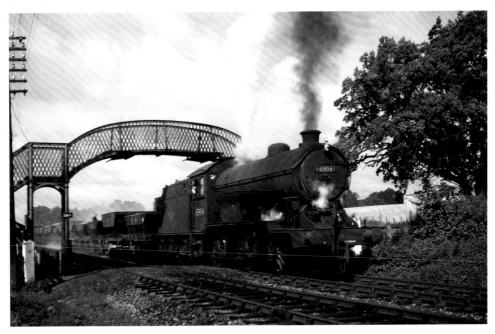

CLACKMANNAN

A few miles west of Bogside, 65934 was encountered again on its ballast train, this time actually in the process of ballasting. This was almost at the junction for Alloa, which regained its train services from Stirling in 2008.

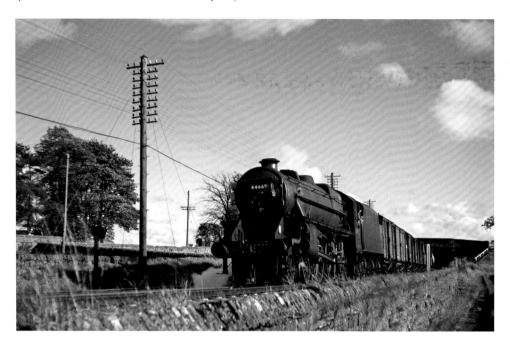

YANWATH, Near Penrith

A short visit was made to the WCML on 12 September 1966 while staying in the Lake District. Here is Black 5 44669 on a goods.

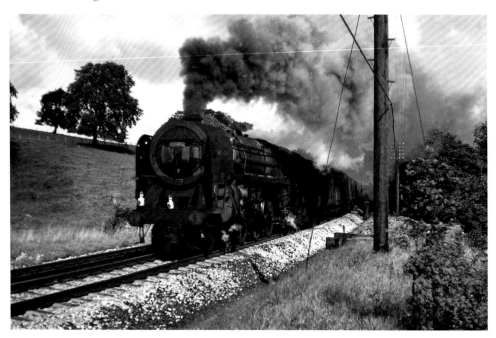

THRIMBY GRANGE, Near Shap

Another fleeting call, this time at Thrimby on 13 September 1966 where Britannia class 70018 *Flying Dutchman* stormed through in a very dilapidated state. It was sad to see a class that I remembered in pristine condition on the GE line getting to such a level of neglect.

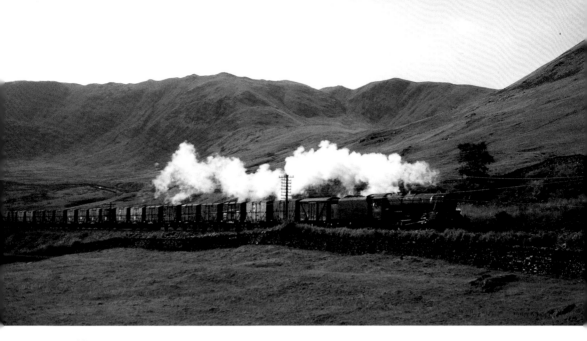

Near TEBAY

A short stop on our return from holiday on 16 September 1966 was near Tebay where an unidentified Black 5 on a container train (old style) came past, climbing the gradient.

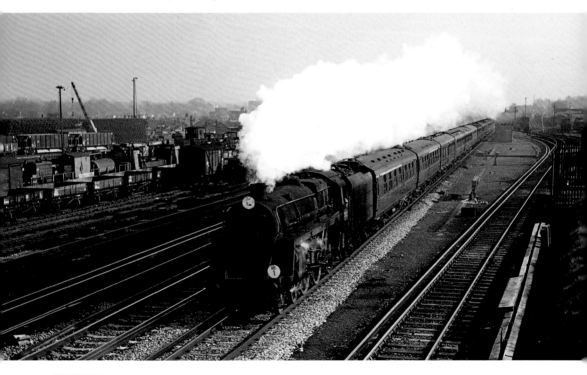

WOKING

Southern steam was now the priority, with a visit to Woking on 1 April 1967. My Petri camera being in for repair, I hired a Contax, little knowing that I would own two of this make, albeit in SLR form in the eighties and nineties. Here is BR Standard 5MT 73085 *Melisande* going nicely through Woking Sidings.

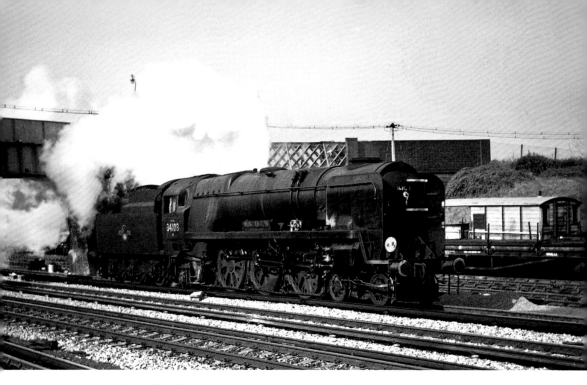

Light engine Mod. West Country 34108 *Wincanton* passes at the sidings. Despite losing her smokebox numberplate she seems to be still hanging on to her name!

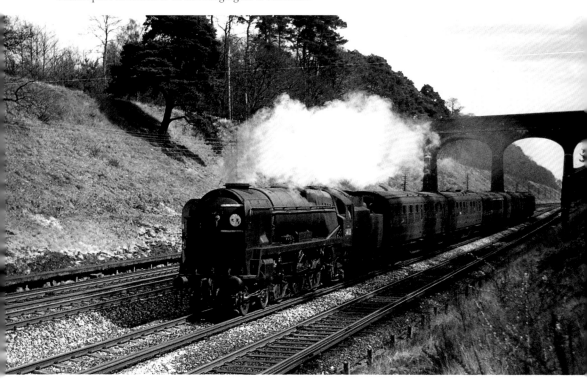

DEEPCUT Cutting

34108 *Wincanton* again, now heading west at Deepcut on her train.

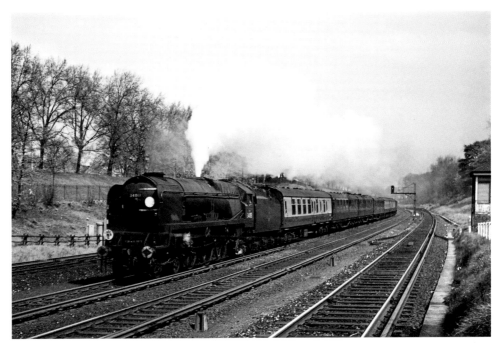

CLAPHAM Cutting

Mod. West Country 34013 *Okehampton* in Clapham cutting on 30 April 1967.

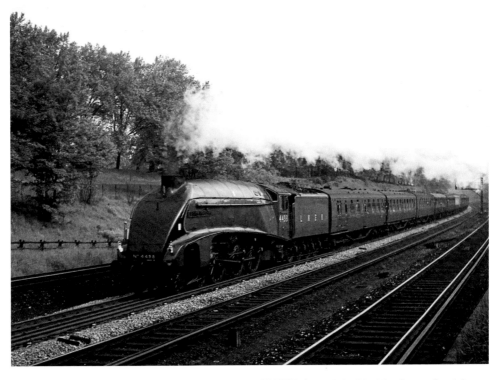

Clapham cutting again, but on 3 June 1967 with preserved LNER A4 4498 *Sir Nigel Gresley* on a Special.

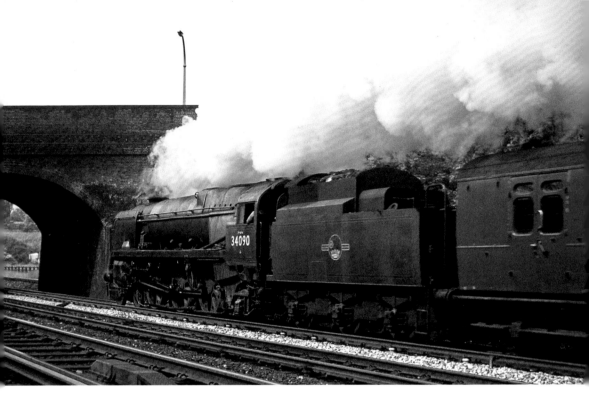

Mod. Battle of Britain 34090 *Sir Eustace Missenden* passes. Most of the remaining SR locos seen were looking rather smart and had obviously been spruced up for the last month of working.

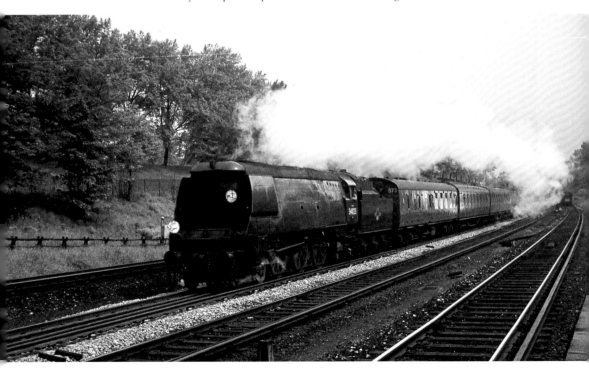

Unmod. West Country 34023 *Blackmore Vale* hurries past, looking splendid despite the loss of her nameplate. Steam on the Southern was due to finish on 9 July and this visit to the line was my last.

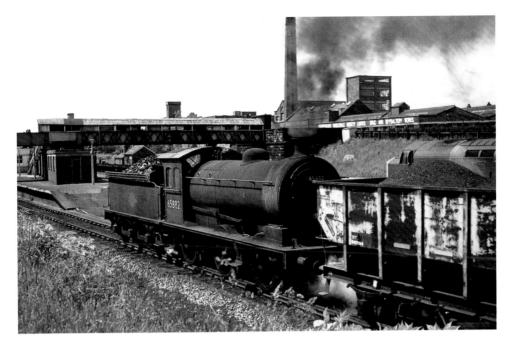

PELAW

On a week's holiday with my railway friend, and this time in my own car, calling in at Pelaw near Sunderland we saw J27 65882 on a coal train – almost a station shot but taken outside so it just makes inclusion here. Photographed on 21 June 1967.

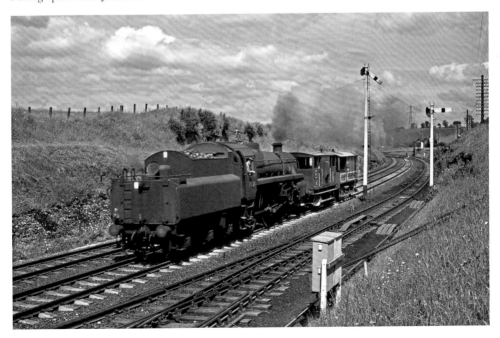

THRIMBY

We also visited the Shap area, and at Thrimby on 23 June 1967 BR Standard 4MT 75024 brings two brake vans past the signal box.

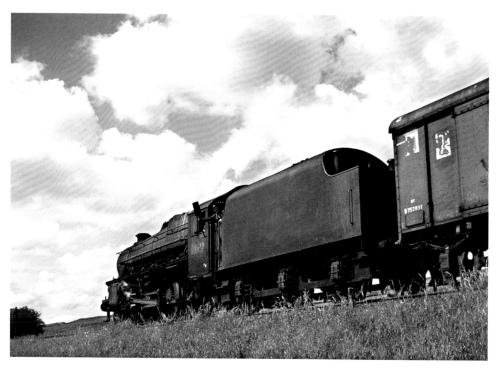

SCOUT GREEN, Shap

The fireman on Black 5 44852 seems to be enjoying a break – and letting the banking 4MT on the rear of the train do all the work! Photographed on 23 June 1967.

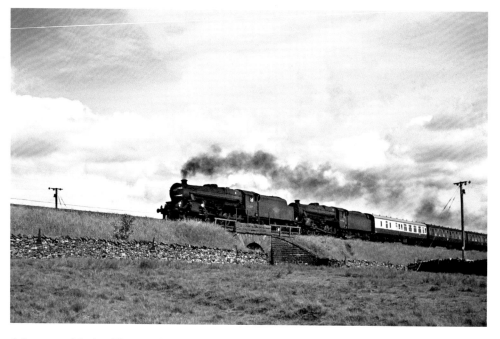

A foretaste of the last BR steam Specials – Black 5s 45227 and 44692 cope easily with the grade on a rare passenger train on 23 June 1967.

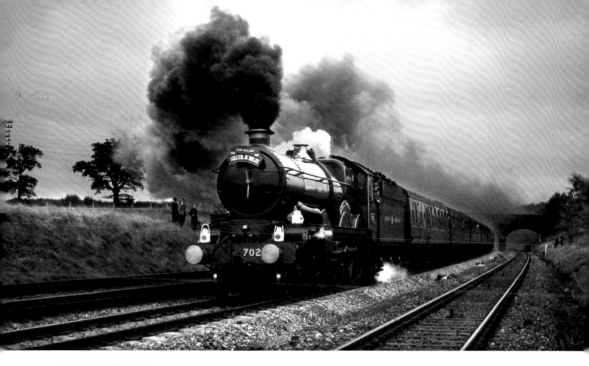

BROOKMANS PARK, GN Line

Steam on the Great Northern again, with preserved GWR 7029 *Clun Castle* on an Ian Allan Special on 8 October 1967.

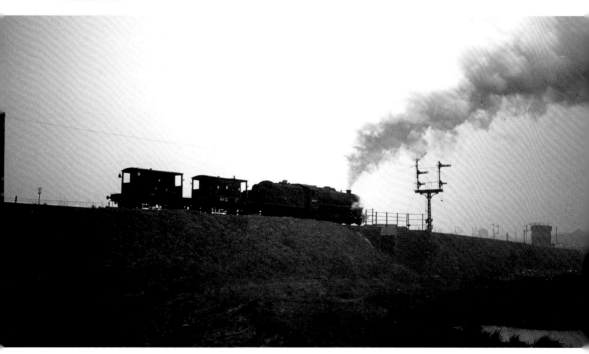

SPRINGS BRANCH, Wigan

A few days were spent Up North in late February/early March 1968 to primarily visit the remaining steam sheds in the Liverpool–Manchester area. On 1 March 1968 5MT 44947 propels two brake vans up the grade at Springs Branch.

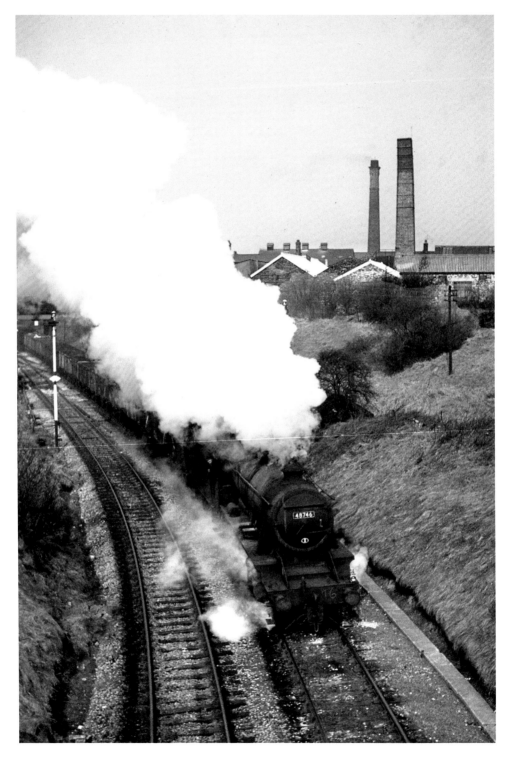

EDGE LANE JUNCTION
Leaking steam, 5MT 48746 makes a spectacle at the junction. Photographed on 29 February 1968.

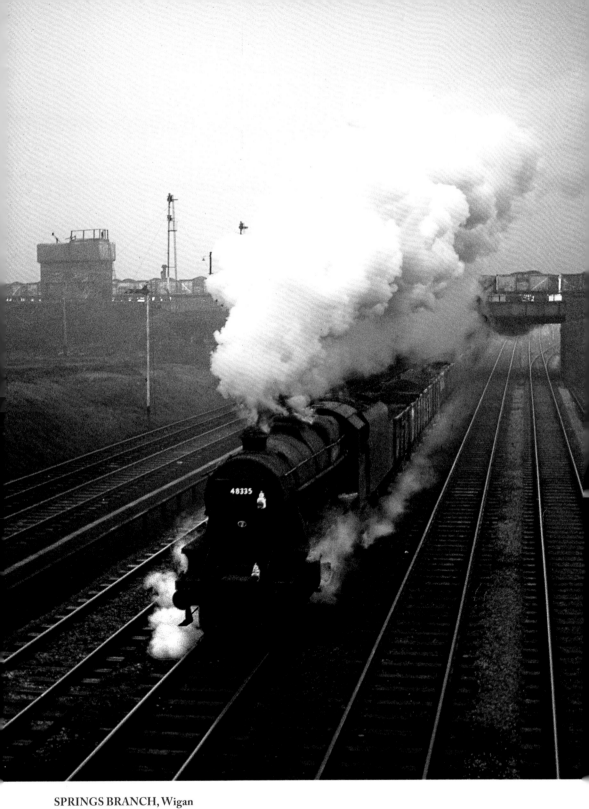

SPRINGS BRANCH, Wigan

More steam from all parts of 8F 48335 as it brings a coal train past, on 1 March 1968.

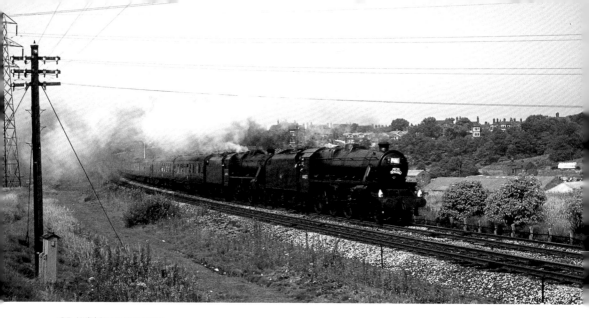

CLAYTON BRIDGE

Sunday 4 August 1968 was the day of the last BR steam Specials and it was a must to attend. Leaving my holiday accommodation in Aberystwyth early in the morning I got to Manchester to pick up two friends who had travelled up from London. Here is the first SLS Special, double-headed by 5MTs 44871 and 44894.

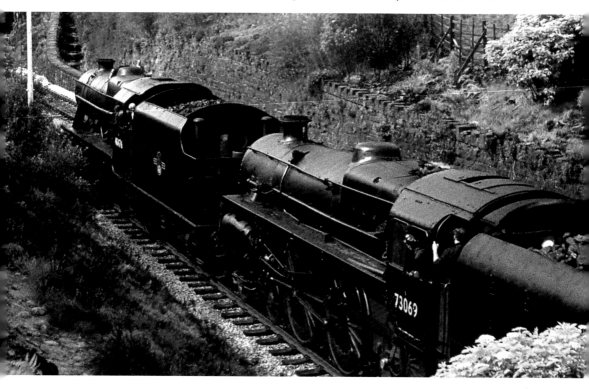

ENTWHISTLE

There were quite a few different Specials running that day , and what with late running it was difficult to see the planned favourites. Here is the RCTS Special, a little different, with an unlined black Standard 5MT, 73069 and a 8F, 48476. My last BR steam lineside shot.

Chapter Three

Stations

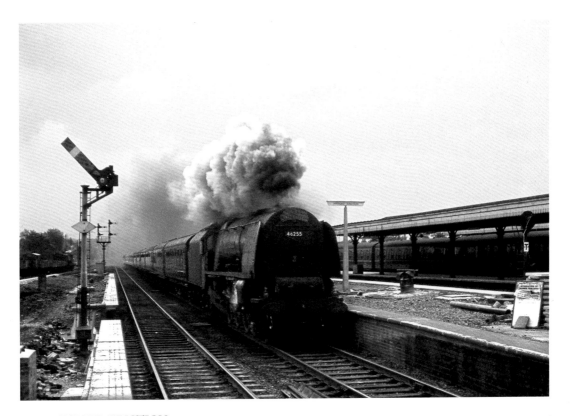

WATFORD JUNCTION

Duchess 46255 *City of Hereford* powers through the station with the Lakes Express on 17 August 1963.
Although difficult to tell in this view, she was one of the rarer green-liveried locos – and the use of a headboard
at this date was pretty unusual too.

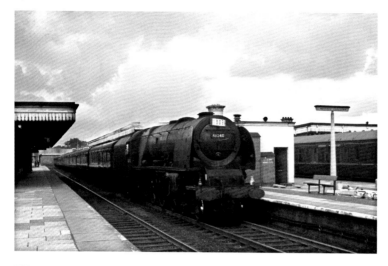

A red-liveried 46240 *City of Coventry* arrives on a semi-fast.

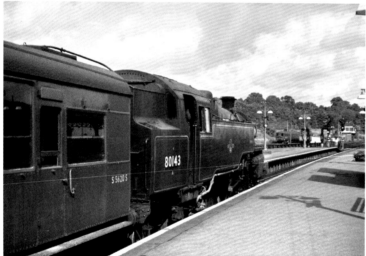

GUILDFORD

My first SR trip to travel on the Guildford–Reading line. At Guildford station on 31 August 1963 is BR Standard 4Mt tank 80143, pulling out empties.

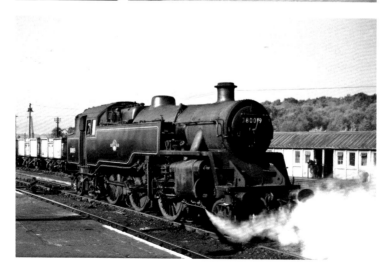

TUNBRIDGE WELLS

On my visit here on 12 October 1963, I was hoping to find H class 0-4-4 tanks but I was too late. Ivatt 2MT tanks had taken over the services. While here, BR Standard 4MT tank 80019 posed in the sunshine.

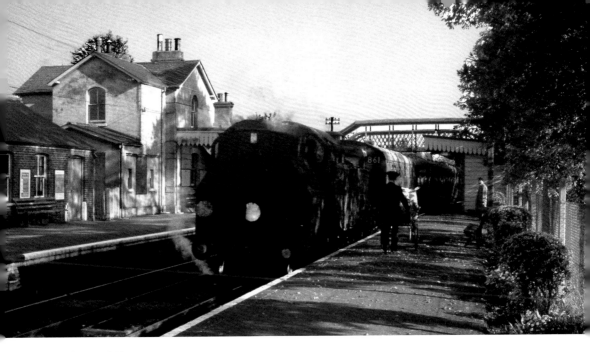

CRANLEIGH

On my journey from Horsham to Guildford, our Ivatt 2MT 41326 stopped for fifteen minutes at this delightful station, enabling a break on the platform. A laden trolley being pushed along completes the picture.

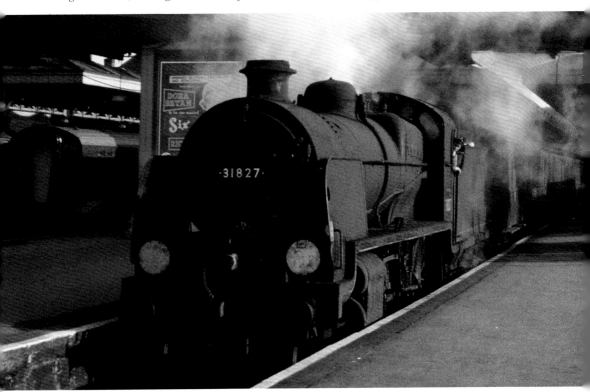

GUILDFORD

N class 318927 departs on a Reading train.

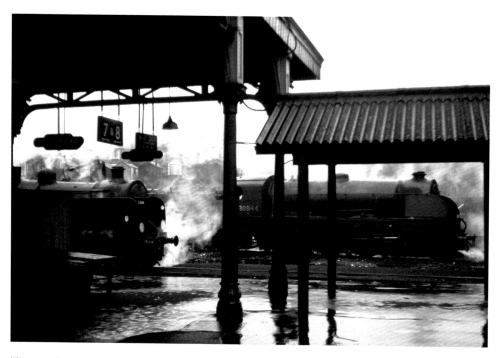

The view from the platforms at Guildford on a wet 14 March 1964, with S15 30844 and N class 31866.

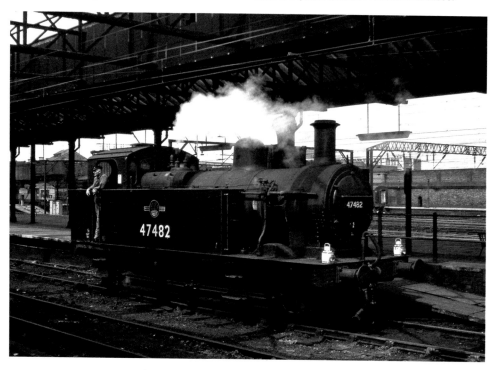

CREWE

3F tank 47482 awaits pilot duties at Crewe – recently outshopped with a tankside in lieu of a bunkerside number. Taken on the first day of my MR Railrover week, Monday 22 June 1964.

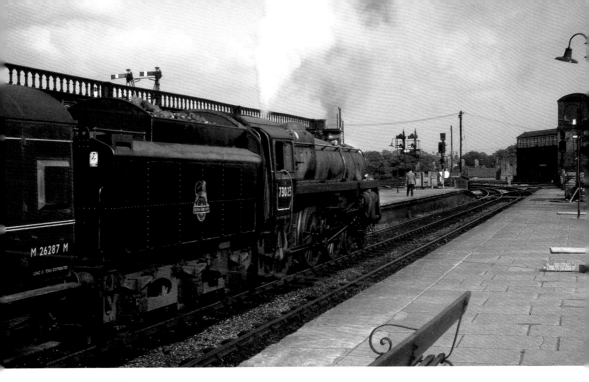

SHREWSBURY

My target station on the Monday, reached from Paddington. BR Standard 5MT 73025 waits to depart. Note the early BR Lion & Wheel emblem on the tender.

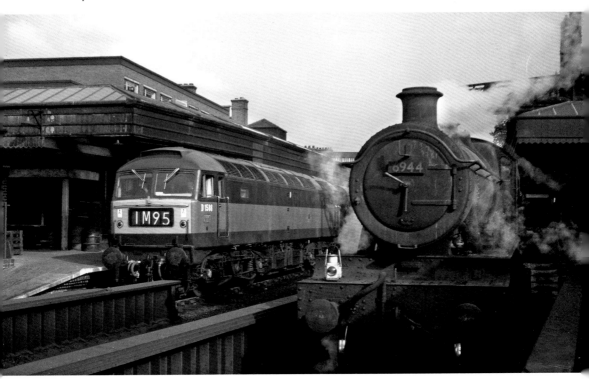

A contrast in motive power – with 6944 *Fledborough Hall* looking pretty grimy – and new diesel D1596.

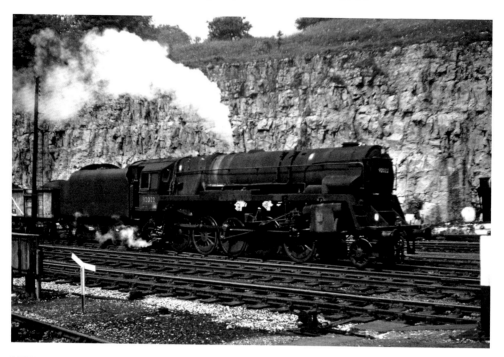

MILLERS DALE

This station in the Peak District was my second day's destination on my Railrover week, reached from St Pancras. Crosti-boilered 9F 92022 passes through on a mineral train.

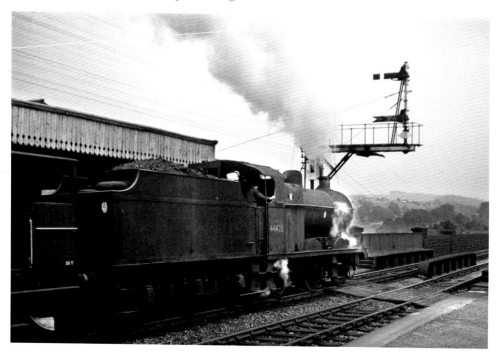

4F 44420 pulls away from the station on a PW train. Photographed on Tuesday 23 June 1964. This spot was revisited in 2003, it now being a walking trail – the platforms were virtually all that was left.

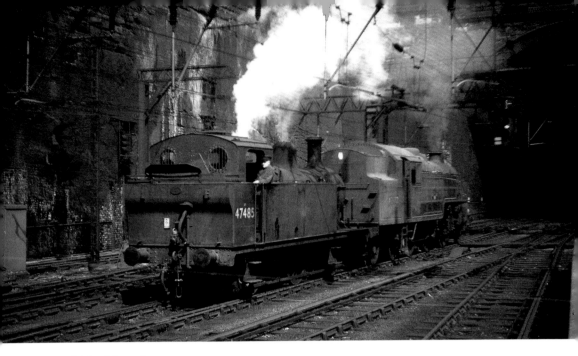

LIVERPOOL Lime Street

Wednesday 24 June 1964, and at last using Euston to depart on my Railrover, I reached Liverpool via Chester and Birkenhead – with my first Mersey Ferry crossing. Lime Street was a bit of a cavern but the sun penetrated to shine on 3F tank 47485 coupled to 4MT tank 42132 backing on pilot duties.

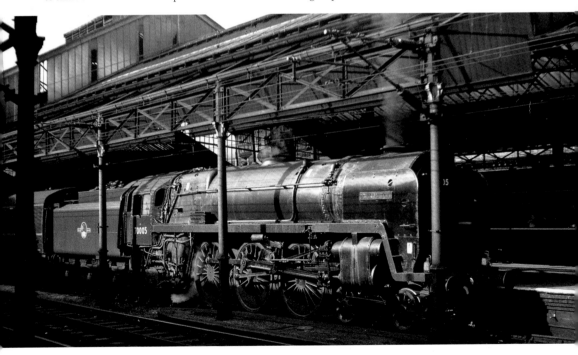

CREWE

This station was a magnet all week, with a stop-off here on most days. On this Wednesday, Britannia class 70005 *John Milton* awaits departure. This loco had been repainted in unlined green, so keeping a smart appearance for its last few years.

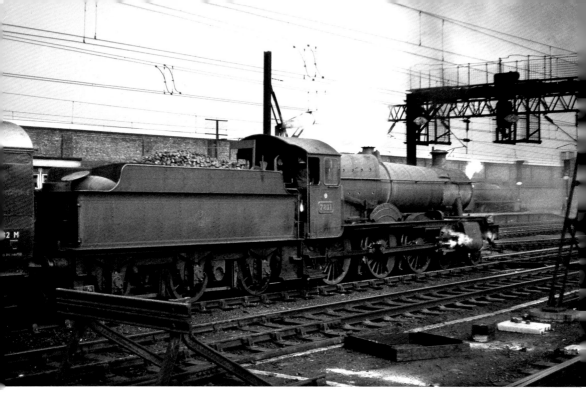

The next day – again calling in at Crewe on my Great Central day from Marylebone to Sheffield, Thursday 25 June 1964. An unexpected sight here was WR 7811 *Dunley Manor*.

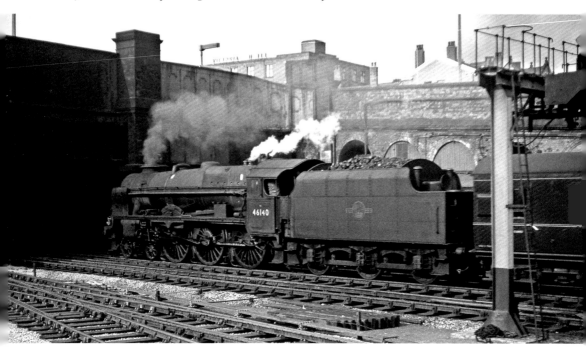

PRESTON

A stop-off at Preston on my way to Carlisle, produced a decently clean Royal Scot loco, 46140 *The Kings Royal Rifle Corps*. Friday 26 June 1964.

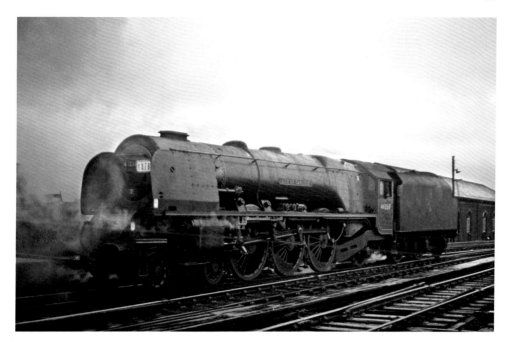

CARLISLE

Having stayed at the County Hotel (right by the station) overnight, I was able to spend the morning of Saturday 27 June 1964 at the station. An early arrival was Duchess 46238 *City of Carlisle*, here coming off her train.

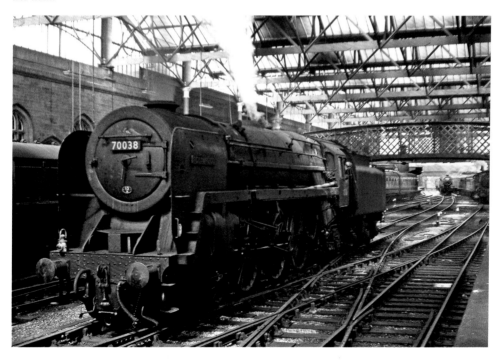

Britannia class 70038 *Robin Hood* positioning under the overall roof. This loco was to haul my train returning south over the Settle & Carlisle.

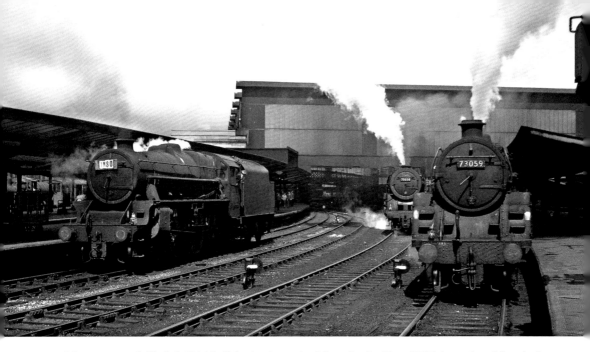

A busy scene with Black 5 45194 (left) having just arrived from Ayr, 'my' loco 70038 (centre), and Standard 5MT 73059 waiting for departure.

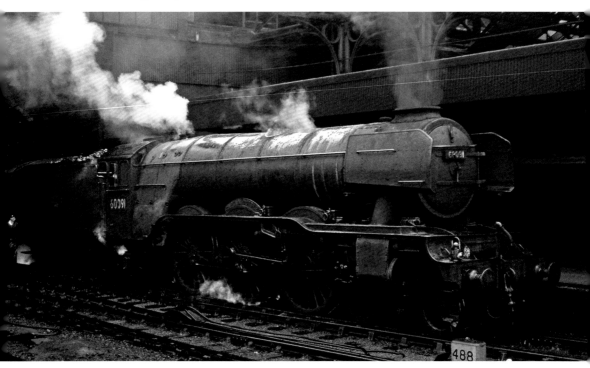

NEWCASTLE

Another long rail trip but this time travelling overnight, trying to catch some sleep in a normal compartment. Unfortunately the weather was bad and photography was difficult. Waiting to depart is A3 60091 *Captain Cuttle*, looking nothing like the A3s I was used to at Kings Cross – to be expected I suppose, as she had only three more months before withdrawal. Photographed on 18 July 1964.

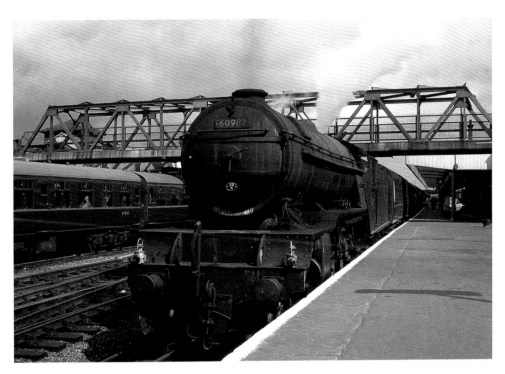

DONCASTER

At Doncaster, on a trip to York, I found V2 class 60982 on an express here. 1 August 1964.

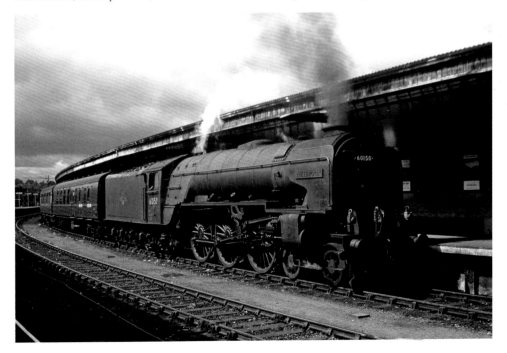

YORK

The only A1 seen here, 60150 *Willbrook* awaits departure. Two months to go, then scrapped.

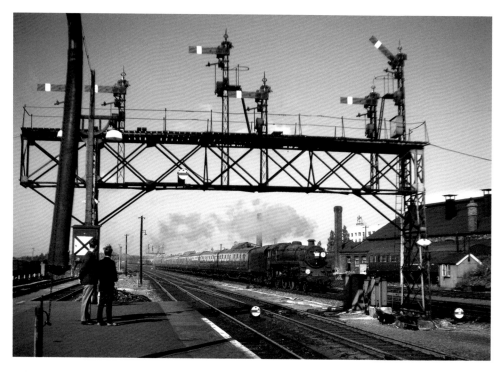

BASINGSTOKE

Stopping off here on my way to Salisbury on 29 August 1964, with BR Standard 5MT 73115 framed by the superb signal gantry.

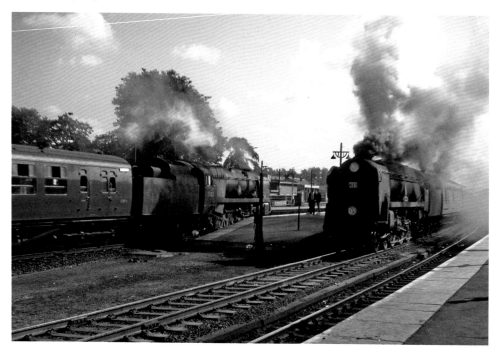

Merchant Navy class 35021 *New Zealand Line* (left) passes Mod. Battle of Britain class 34082 615 *Squadron*.

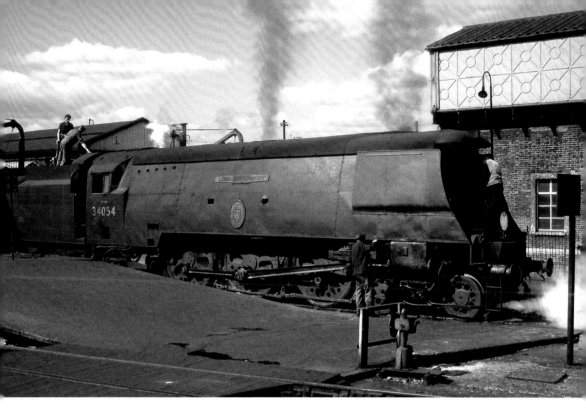

SALISBURY

Unmod. Battle of Britain 34064 *Lord Beaverbrook* receives attention.

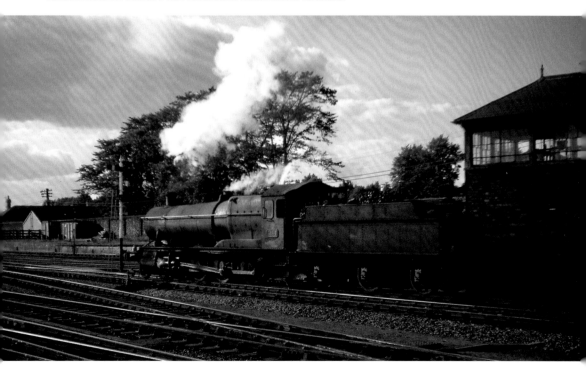

WR 28xx class 3864 steams off to the shed.

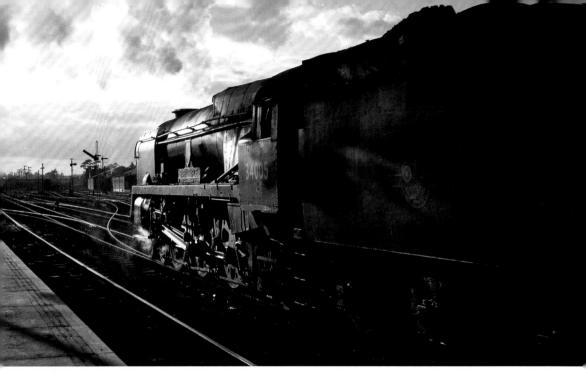

Mod. West Country 34005 *Barnstaple* heads into the evening sun on a goods.

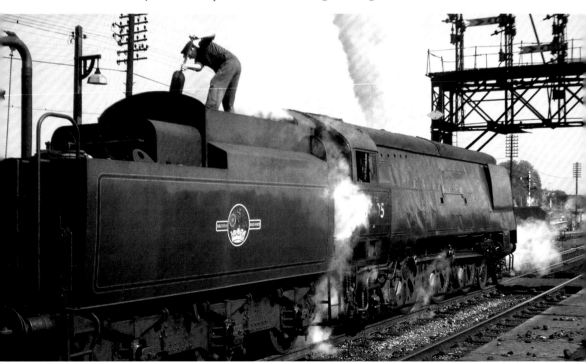

BASINGSTOKE

Another call at Basingstoke on 12 September 1964, after seeing *Flying Scotsman* earlier. Unmod. West Country 34015 *Swanage* pauses at the station amid much blowing off. The fireman pulls forward more coal while waiting. *Swanage* is now preserved at the Mid-Hants Railway.

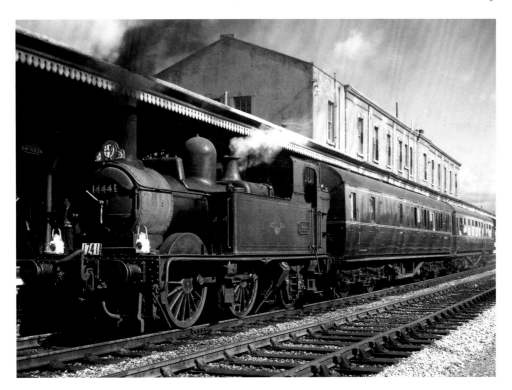

SWINDON

One of two Specials at Swindon on 20 September 1964. 0-4-2 Tank 1444 was running a two-coach train.

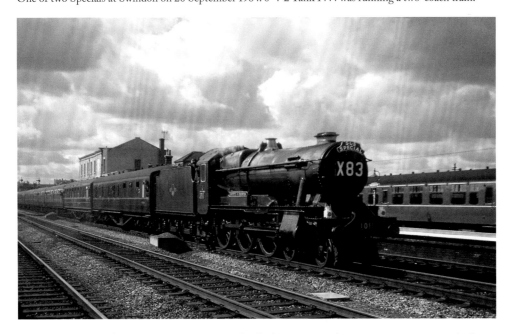

The other Special had 1011 *County of Chester* at its head – here arriving, the occupants to go on to a shed visit. The loco had been given a GWR touch, with its number on the bufferbeam, as well as having undergone much cleaning.

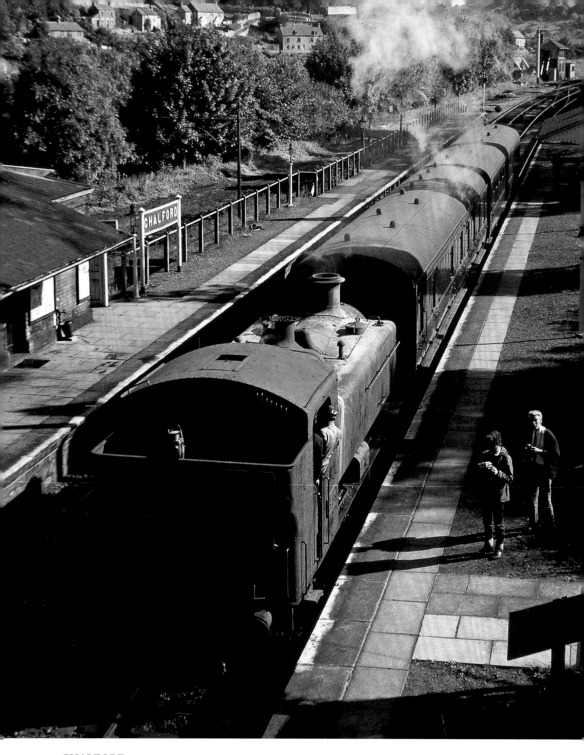

CHALFORD

The Gloucester–Chalford service was one of the few remaining 'Auto-train' (push-pull, with the driver controlling the train from the carriage end if the loco was 'pushing') services and a visit was made on 26 September 1964 to see this before it closed at the end of October. The train pictured here though was not an 'Autotrain', the Pannier tank 9453 having to run round before departing.

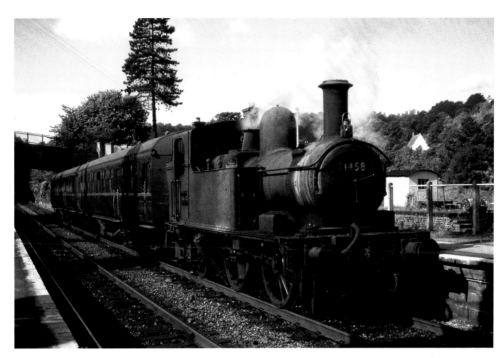

Fortunately the next train to arrive on this service WAS a proper 'Autotrain' with 0-4-2 tank 1458 at its head. Note the absence of top-feed apparatus on this loco.

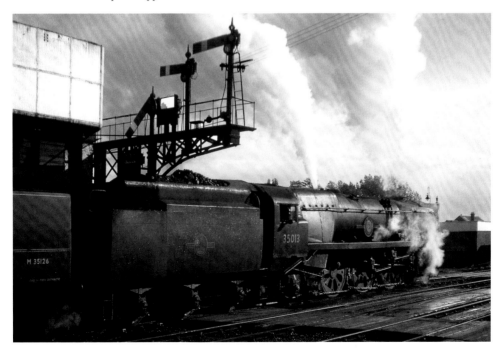

OXFORD

This turned out to be a good spot to see multi-regional trains such as the Pines Express, here pulling away with Merchant Navy 35013 *Blue Funnel* at its head.

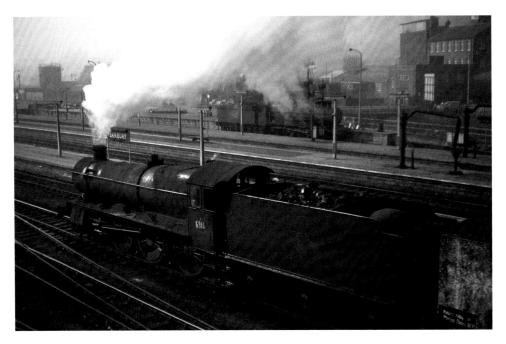

BANBURY

Two Halls at Banbury on 3 April 1965 – 6916 *Misterton Hall* with a goods and 6951 *Impney Hall* light engine in the distance. All WR locos looked in a sorry state in their last year with name and numberplates removed. I was here to see *Clun Castle* on a Special – the pristine appearance being in sharp contrast to these Halls.

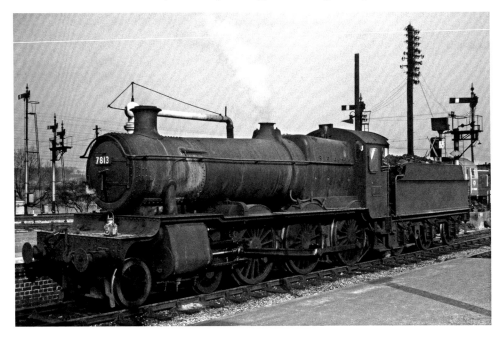

DIDCOT

Also photographed on 3 April 1965, and also looking very down-at-heel is 7813 *Freshford Manor*, light, at Didcot Station. At least she had managed to hold on to her cabside plate.

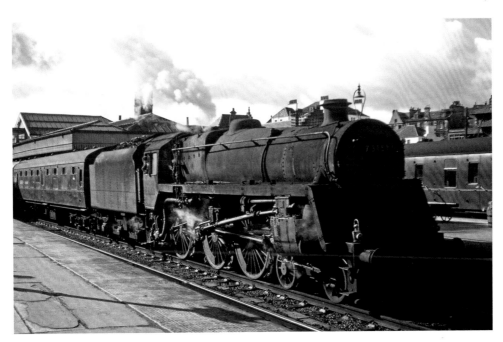

STIRLING

On my Scottish weeks' holiday – at Stirling Station on 26 August 1965, BR Standard 5MT (Caprotti) 73151 waits with a Dundee train.

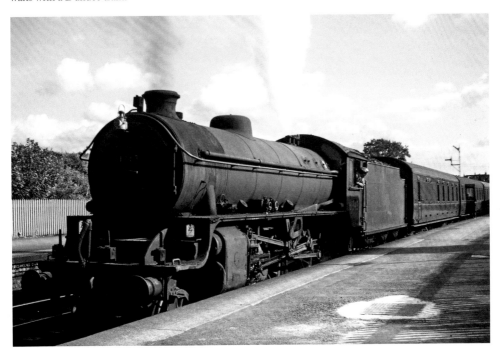

INVERKEITHING

The only B1 seen that week on a passenger train, 61343 with an Edinburgh–Dundee train. The stock is non-corridor. Photographed on 26 August 1965.

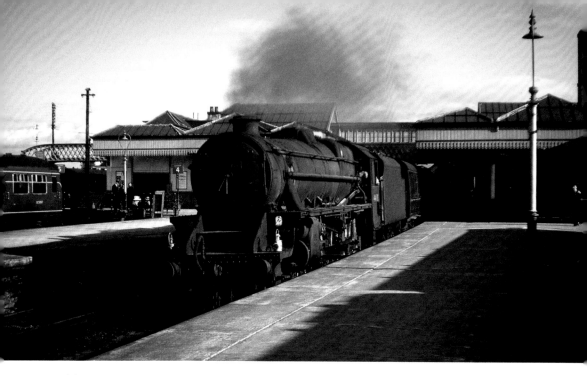

STIRLING

Back at Stirling, Black 5 44718 arrives on a Glasgow–Dundee train.

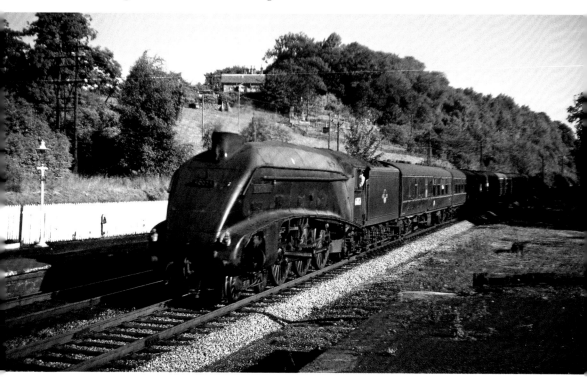

BRIDGE OF ALLAN

A4 60024 *Kingfisher* brings the southbound Bon Accord downgrade through the station.

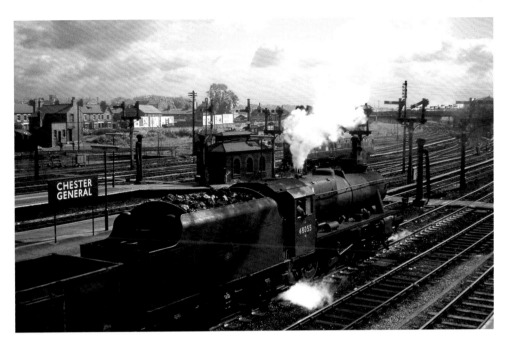

CHESTER

Staying on holiday in Llandudno, I was able to take a day out to see Chester and Chirk. Here at Chester Station is 8F 48055 on an empty wagon train. 1 September 1965.

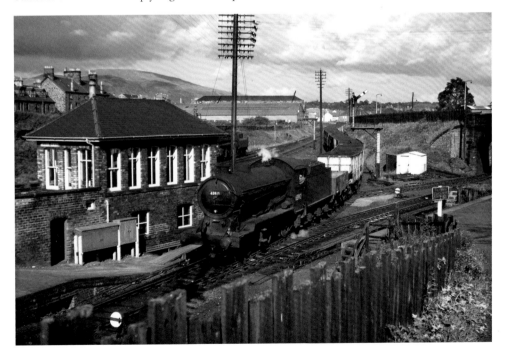

ALLOA

From my 1966 Scottish week – J38 65912 brings a coal train from the Dollar branch through the station. Photographed on 7 September 1966.

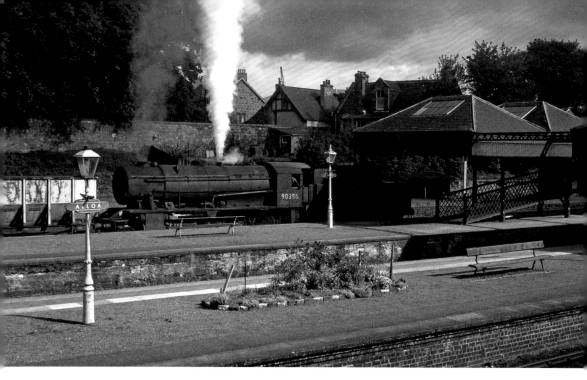

A return visit to Alloa the next day with WD 90386 waiting and blowing off steam. This station was an easy one to photograph, these shots being taken from the road.

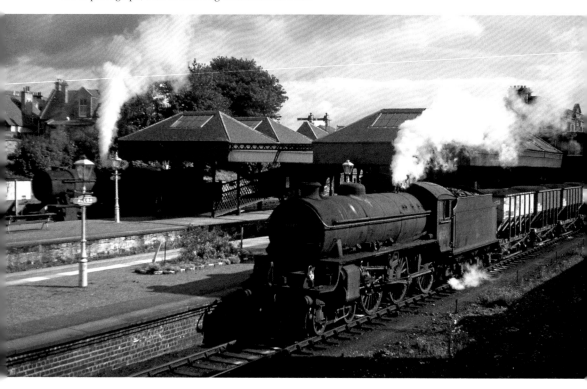

With the WD still waiting, B1 61340 runs through. Nothing now remains – the new Alloa Station being built a few hundred yards away from the old site.

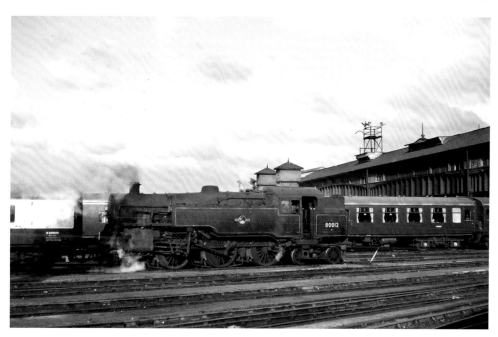

CLAPHAM JUNCTION

Back down south for a visit to one of steam's last strongholds. On 25 October 1966, BR Standard 4MT Tank 80012 shunts blue/grey stock. Note the unrelieved blue on the main line stock in the background.

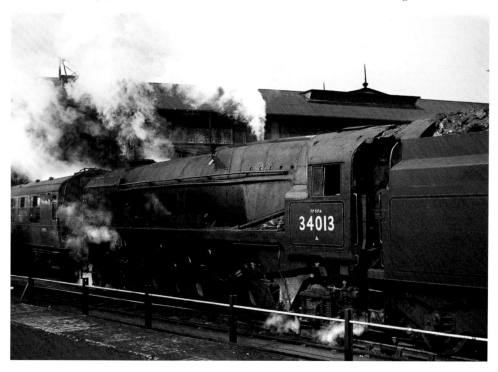

On 30 April 1967, with just a few months to go now before the end of SR steam, Mod. West Country 34013 *Okehampton* is used to shunt stock at the carriage sidings.

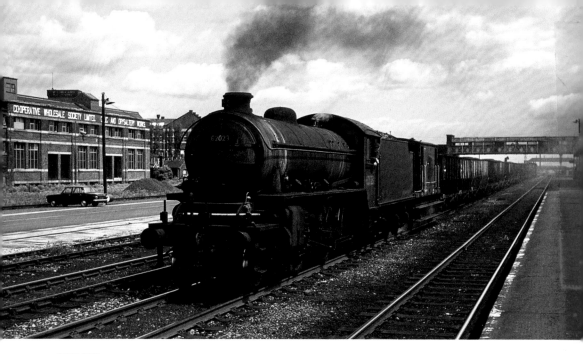

PELAW

Photographed here on my Northern week, on 21 June 1967, K1 62023 brings a coal train into the station. Note the shunting pole resting over the buffers.

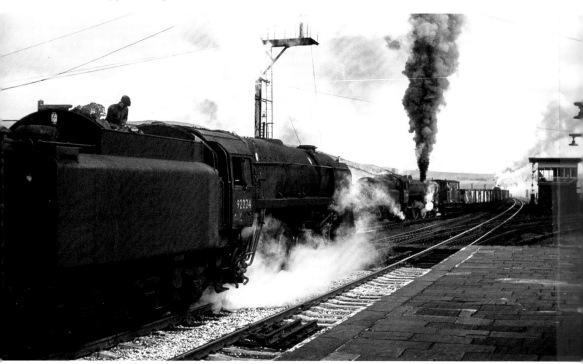

TEBAY

Also on my Northern week, but in the west at Tebay on 23 June 1967. A busy scene at Tebay Station with 9F 92224 waiting for the road, while Tebay banker BR Standard 4MT 75039 banks a train from the loop. Both locos were gone in three months.

Chapter Four

Isle of Wight

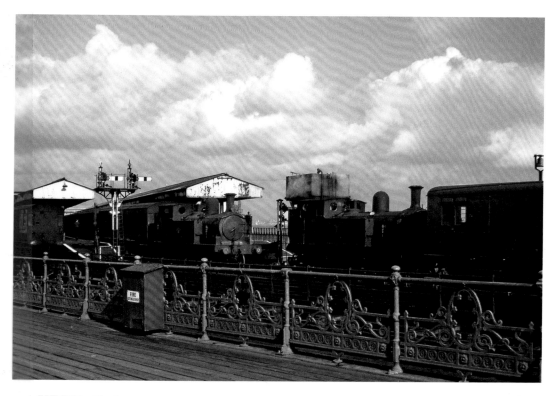

RYDE Pier Head

These IOW images are not in date order but follow the line from Ryde to Ventnor, with the final few on the Cowes line. This view at Ryde Pier Head was taken on 11 October 1964, being my third visit to the island. The trains met the ferries from Portsmouth here, and no better introduction to the island's delights could be had than walking off the ferry to find an O2 tank, waiting impatiently with its Westinghouse brake pump panting away at the head of a rake of vintage carriages. Here we have Nos 17 *Seaview* and 33 *Bembridge*.

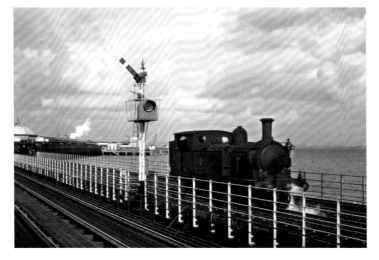

RYDE Pier

On the same day, No. 31 *Chale* runs light on the pier. This is about halfway along the pier, the tracks this side of the fence being a tramway.

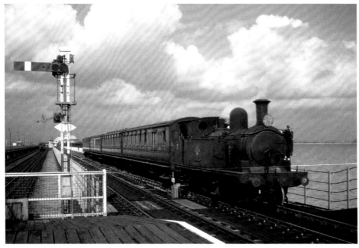

RYDE Esplanade

No. 17 *Seaview* now comes off the pier at Esplanade Station. The pier tramway's petrol-driven vehicle can be seen operating on the left of the picture.

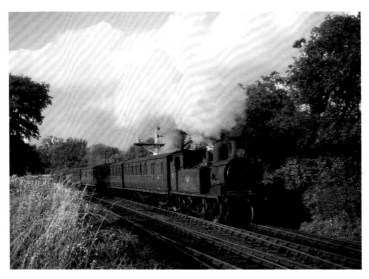

SMALLBROOK Junction

No. 17 *Seaview* again passing the junction signal at Smallbrook. Obscured by the smoke, the signal arms had been removed as the two lines, to Ventnor and Cowes, were run as single lines during the winter season.

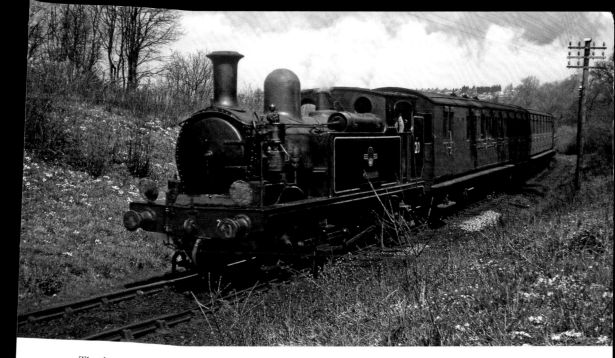

The date is now 24 April 1965 and primroses adorn the lineside at Smallbrook. This view is actually on the curve at the start of the Cowes line and the site of the present interchange BR/IOW Steam Railway station. No. 20 *Shanklin*, spruced up for the summer season, is seen here in one of my favourite IOW shots.

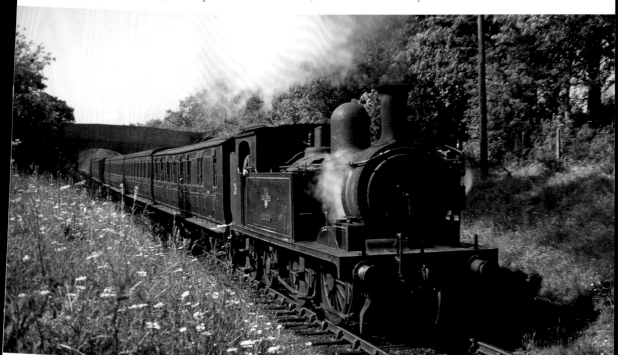

North of BRADING

On Saturday 19 June 1965, No. 26 *Whitwell* amid the daisies in Truckells Cutting, heads for Ventnor. The line was very busy on summer Saturdays and a system of train reporting numbers (here showing number four) was employed.

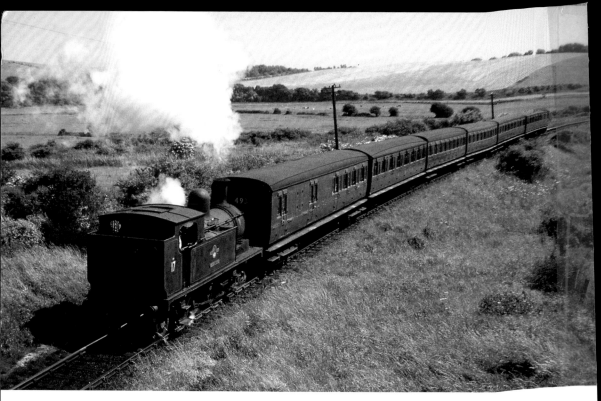

On the same day, No. 17 *Seaview* returns from Ventnor – here, north of Brading.

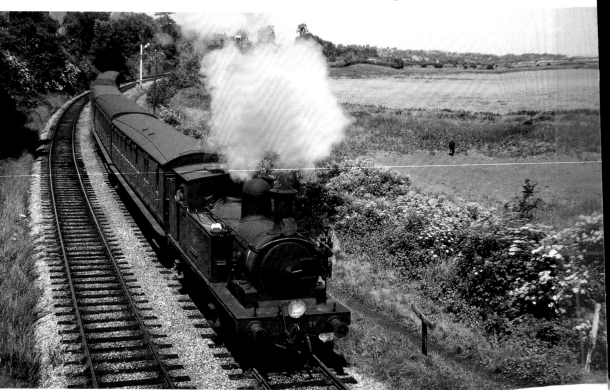

Approaching Brading Station, also on the same day, is No. 29 *Alverstone*.

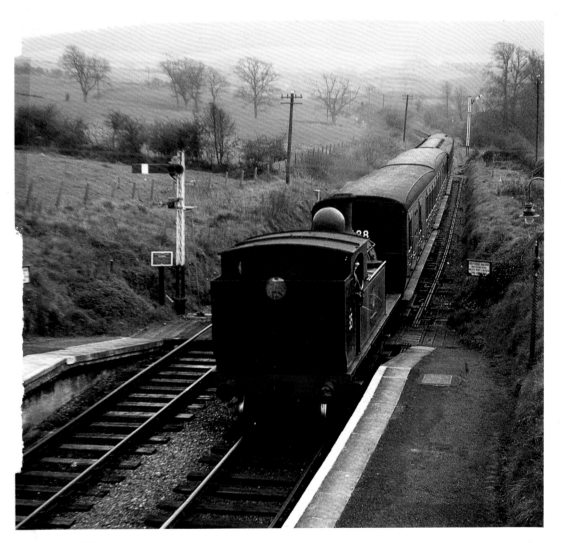

WROXALL

A view of No. 35 *Freshwater* arriving at Wroxall Station bound for Ryde, taken on my first visit to the island on 25 April 1964. This section of line was closed in 1966 and the newly electrified line (using ex-LT Tube stock) reopened only to Shanklin.

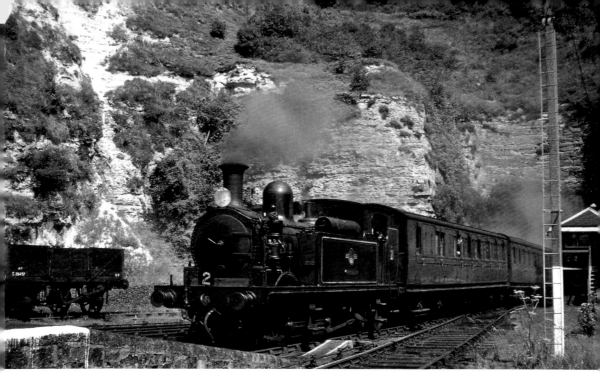

VENTNOR

No. 21 *Sandown* arrives at Ventnor on 17 July 1965. The arrival here was dramatic, having gone through a tunnel (more often than not in complete darkness – with the carriage lights not working) and bursting forth into a chalk quarry, perched high above the sea.

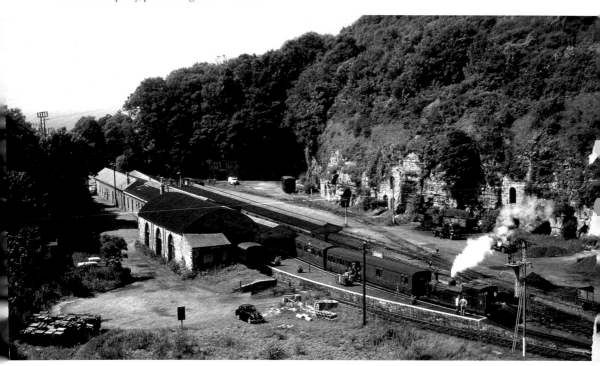

An overall view of the station in its setting, with No. 31 *Chale* awaiting departure. Pictured on 17 July 1965.

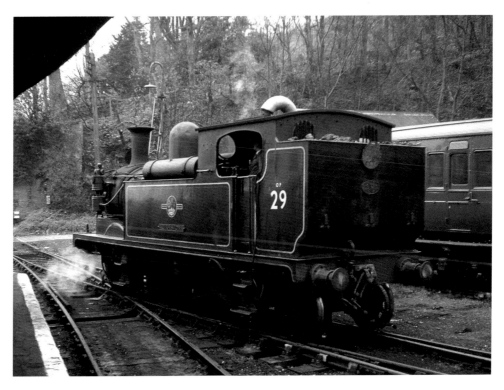

No. 29 *Alverstone* running round at the buffers end of the station – a shot taken on 25 April 1964.

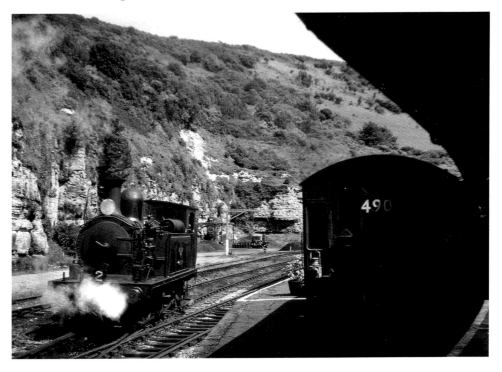

No. 21 *Sandown* runs round on 17 July 1965.

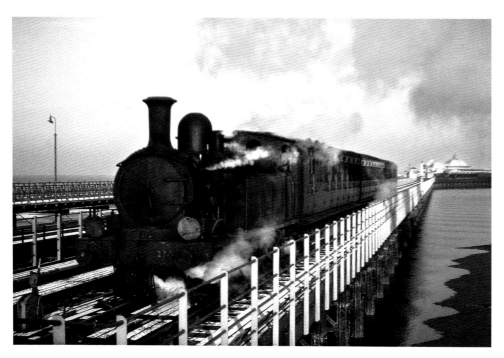

RYDE PIER

The next four images are from my last visit on 15 January 1966, a very cold day, with snow and frost lying. Here is No. 27 *Merstone* coming off Ryde Pier on a Cowes train.

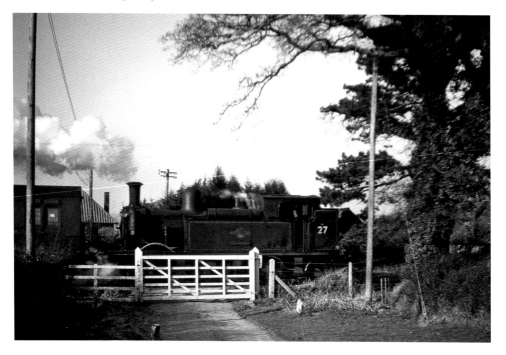

Near NEWPORT

No. 27 *Merstone* returns from Cowes, at a farm crossing near Newport.

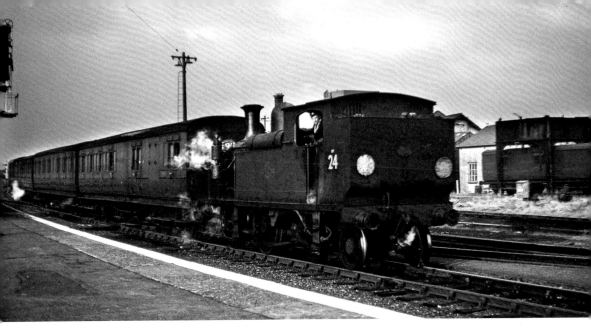

NEWPORT Station

This was as far as I got on the Cowes line. Here is No. 24 *Calbourne* arriving ex-Cowes. This loco was in unlined black after a recent overhaul – and was the only one of the island's locos to be so treated. It had also lost its name.

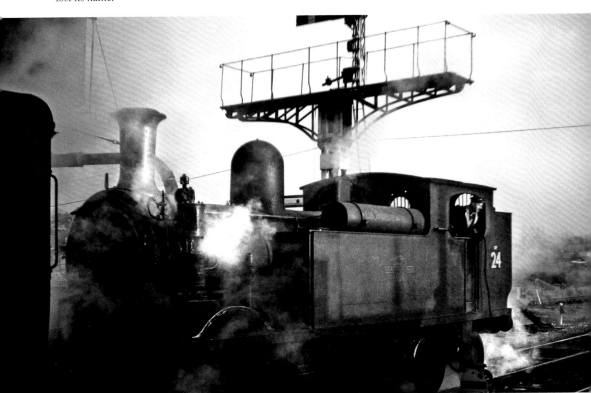

Calbourne waits at Newport. Fittingly my last island shot is of the one O2 that is preserved. The island's steam locos finished up on 31 December 1966.

Chapter Five

On Shed

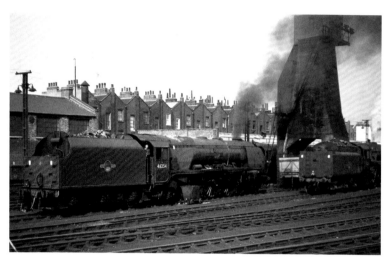

CAMDEN

From the train, passing Camden Shed on 29 May 1963. 46254 *City of Stoke-on-Trent* is being serviced together with an unidentified Britannia. Another Duchess is seen behind the coal stage.

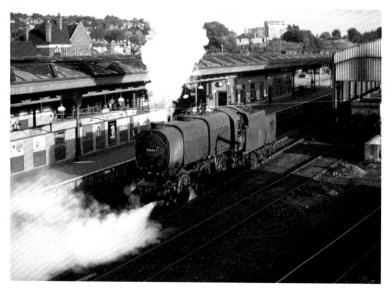

GUILDFORD

One of Bulleid's stranger apparitions was his Q1 class 0-6-0, such as 33035, caught in the late afternoon sun at Guildford servicing/shed area right by the station. 31 August 1963.

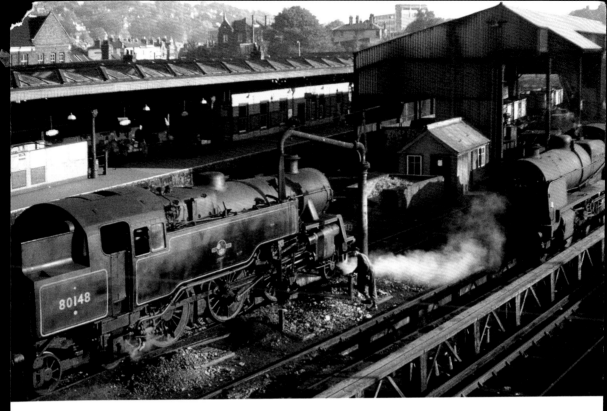

At the same spot on 12 October 1963, BR Standard 4MT tank 80148 takes on water. Also seen is N class 31819.

BASINGSTOKE

Taken from the train leaving Basingstoke on 29 August 1964, S15 class 30887 is on shed, with BR Standard 5MT 73112 *Morgan Le Fay* behind.

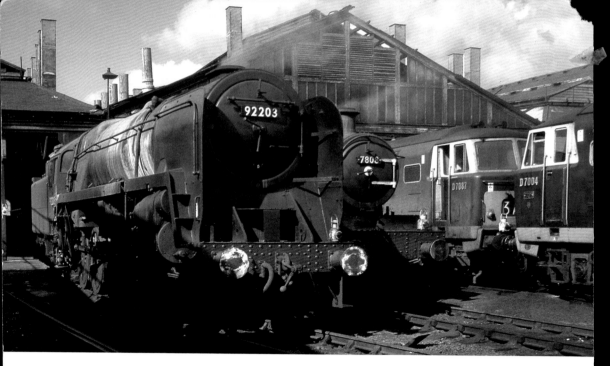

SWINDON

Tagging on to a trainload of enthusiasts who had arrived at Swindon behind *County of Chester*, a rare visit was made inside a shed. Unfortunately my camera was not up to capturing interior shots – but there was interest outside such as 9F 92203 with 7808 *Cookham Manor* in company with a couple of Hymek diesels. This was on 20 September 1964.

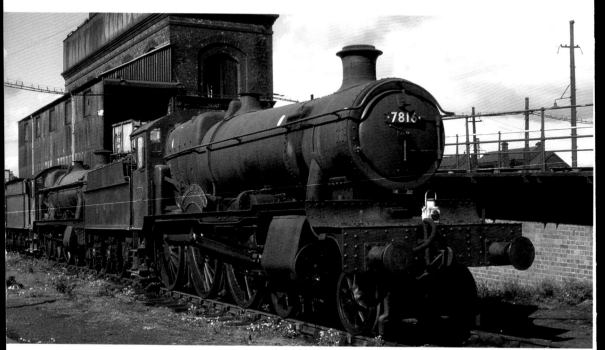

An unusual sight was 7816 *Frilsham Manor* with GWR visible on its tender sides. 7918 *Rhose Wood Hall* is at its rear.

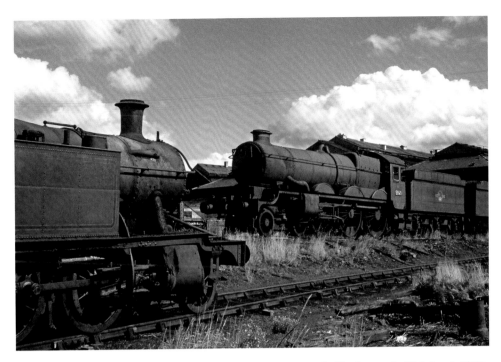

On the scrap line is Castle Class 5060 *Earl of Berkeley*, minus piston rods. The front end of 2-6-2 tank 4569 is also in shot.

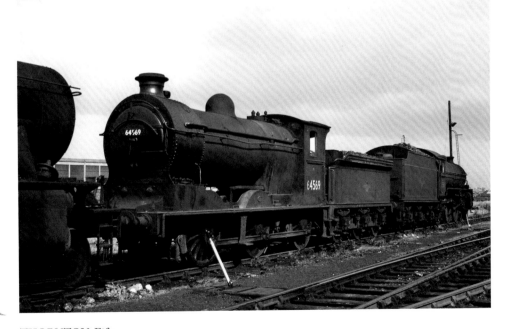

THORNTON, Fife

This was a visit while on holiday in Scotland, and a lucky one as I and another enthusiast were shown around by a driver. An imposing J37 0-6-0 64569 took my eye, with B1 61350. 6 September 1966.

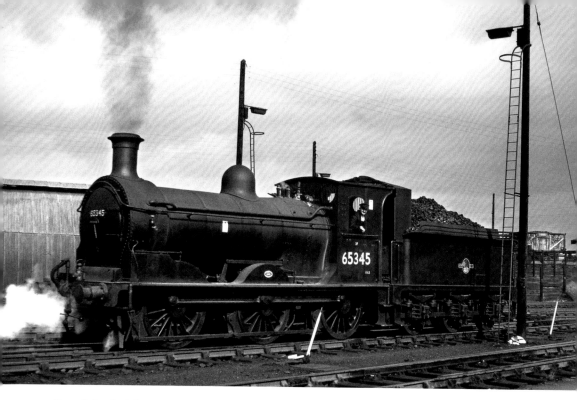

Star of the shed, however, was J36 65345, looking resplendent. She was to be the last steam loco to be withdrawn in Scotland.

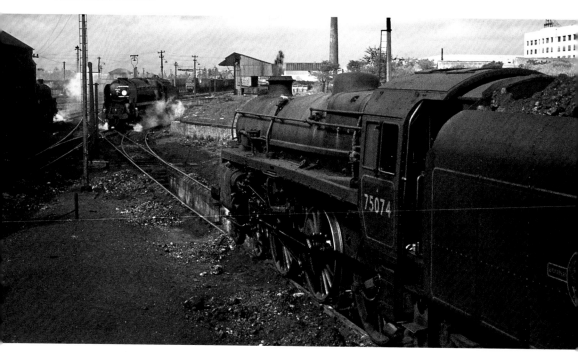

BASINGSTOKE
BR Standard 4MT 75074 with Mod. West Country 34104 *Bere Alston* at Basingstoke shed, just outside the station on 29 April 1967.

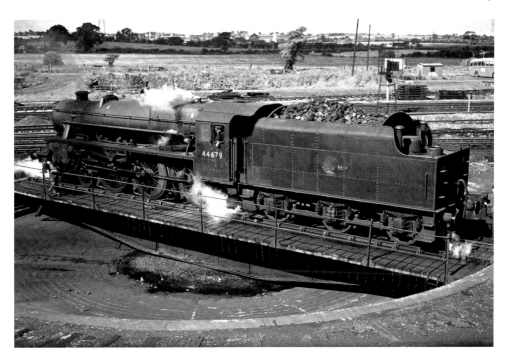

CARLISLE Kingmoor

Visited on my Northern week, Kingmoor shed gave us a fairly clean Black 5 44679 on the turntable there. 22 June 1967.

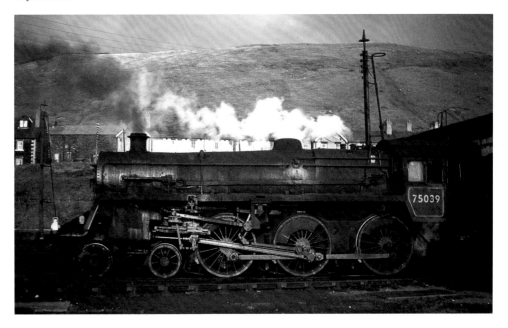

TEBAY

During my weekend visit to the Shap area with two friends, a call in at Tebay shed was made in the evening of 26 August 1967 where we were fortunate to get some very late sunshine. Resting between banking duties is BR Standard 4MT 75039.

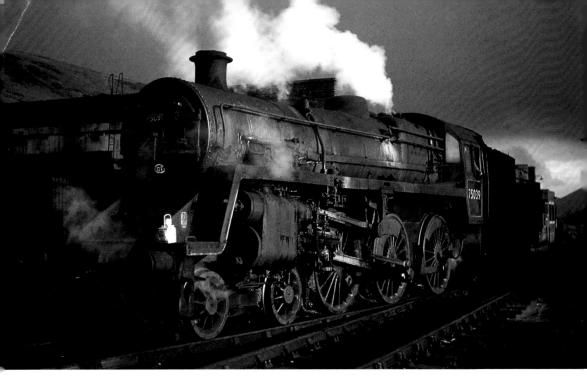

Another view of 75039 awaiting her next spell of banking. We were entertained by the enginemen's comments here on seeing a Britannia on a parcels going hell-for-leather up the bank and not asking for assistance.

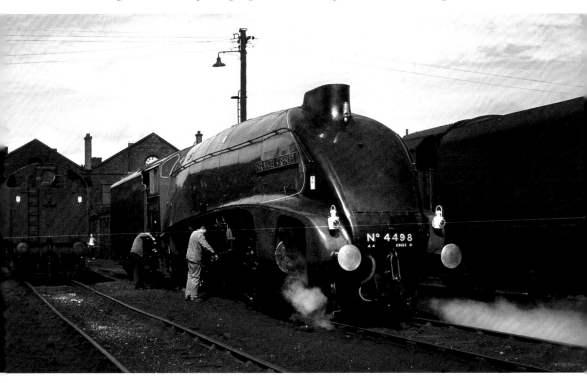

CARLISLE Kingmoor
Preserved A4 4498 *Sir Nigel Gresley* receives attention after bringing in a railtour on 27 August 1967.

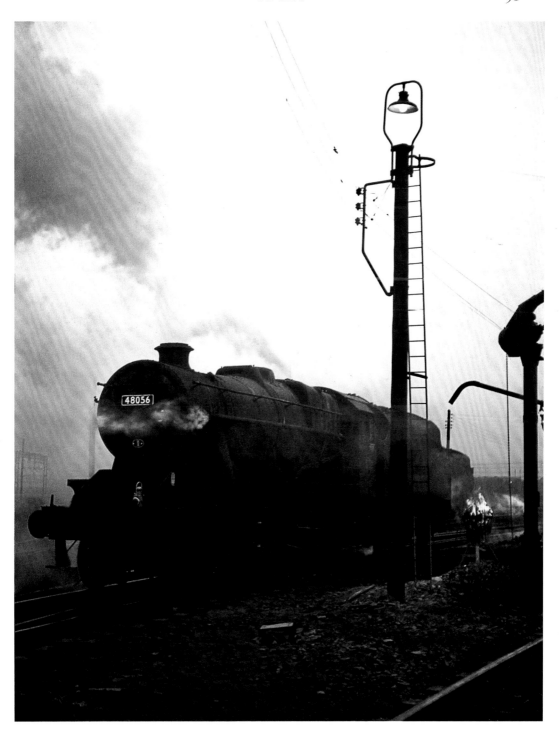

SPEKE

The next six images in this book are from my Shed-Bash in the Liverpool and Manchester area, with a long weekend stay at the end of February and early March, 1968. My friend and I started at 8.00 a.m. on a freezing 29 February morning at Speke shed where 8F 48056 was found – and a warming brazier.

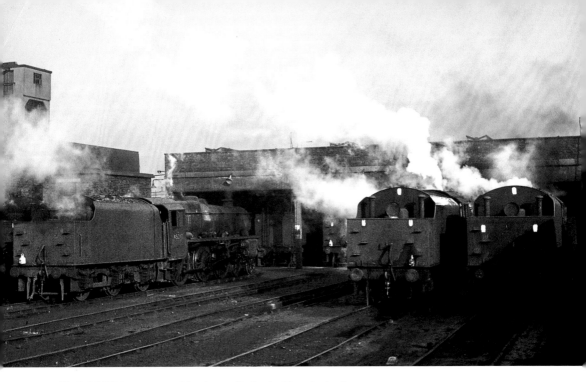

Black 5 45212 in company with others at Speke shed later in the day.

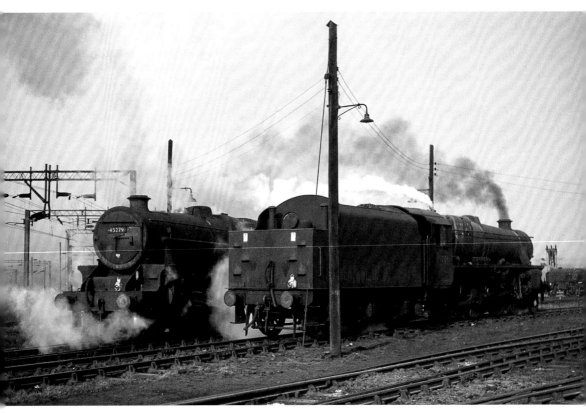

Two Black 5s, fore and aft – 45279 and 45201 at Speke.

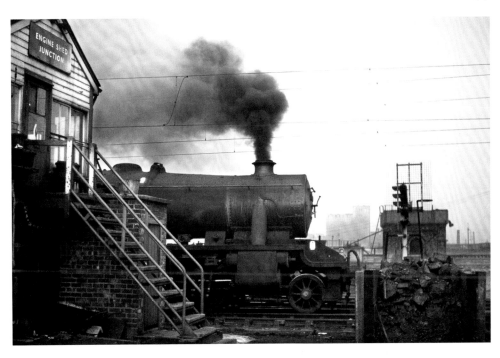

EDGE HILL

8F 48723 by 'Engine Shed Junction' Signal Box.

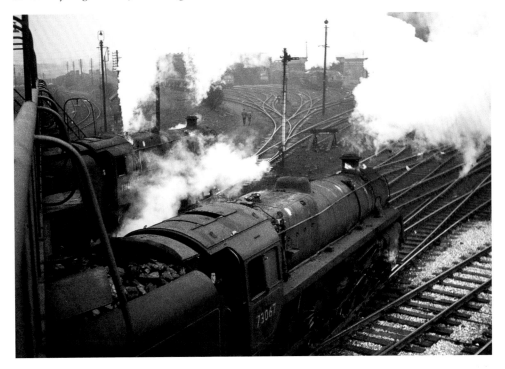

PATRICROFT

A very handy footbridge gave this view of BR Standard 5MTs 73067 and 73125 – visited on 2 March 1968.

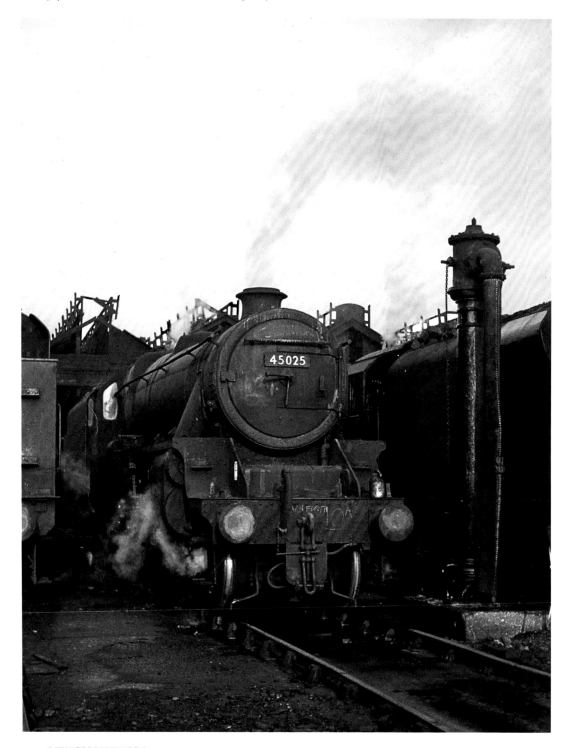

NEWTON HEATH
Weary Black 5 45025 rests in weak sunlight on 2 March 1968. She was one of the last to be withdrawn and is now preserved by the Strathspey Railway.

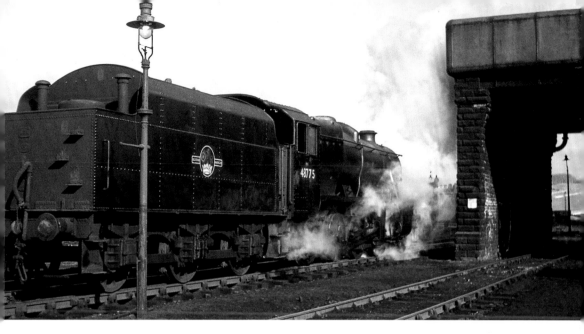

BUXTON

Our return on 3 March 1968 was via the Peak District, where we came across Buxton shed and a very unexpected sight of two very clean 8Fs in steam. Here is 48775 showing that the cleaning enterprise didn't extend to the tender back!

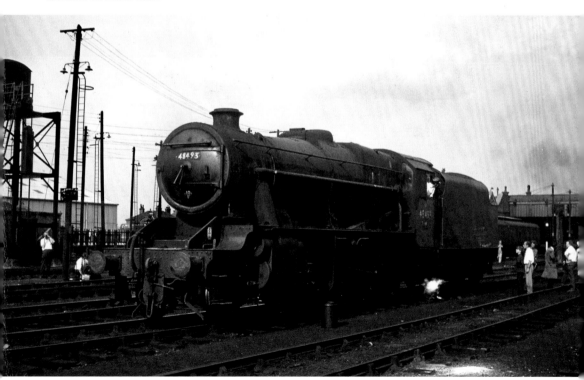

LOSTOCK HALL

Sunday 4 August 1968 and the last BR steam day. The final three images were taken at Lostock Hall shed after we had finished chasing around after the various steam Specials. Here is 8F 48493.

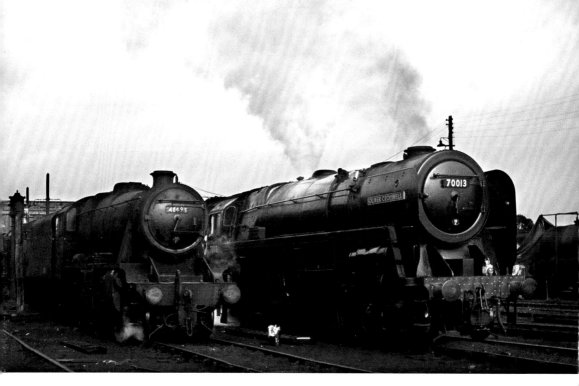

48493 is now joined by Britannia 70013 *Oliver Cromwell*, which had run one of the tours (one we had missed).

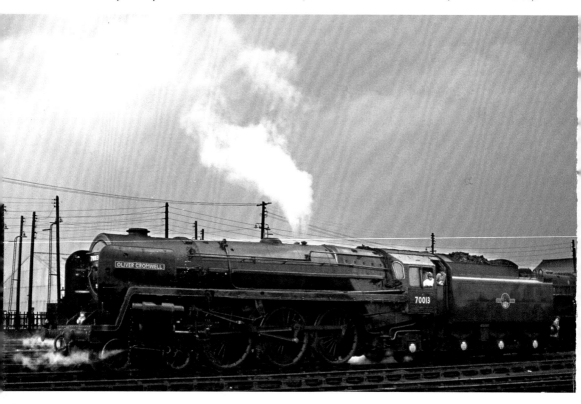

A last look at a beautifully presented *Oliver Cromwell*, which was duly preserved for main line running.